覆寫真實

COVEREDREALITY

臺灣當代攝影中的檔案與認同
Archival Orientation and Identity in Taiwanese
Contemporary Photography

目錄
Contents

部長序

立陶宛與臺灣在許多層面上有相近的歷史情境，在當前全球局勢上也面臨許多類似的處境，近期更因COVID-19的流行，立陶宛向臺灣致送口罩與疫苗而搭起國際友誼的橋樑。這次的臺立攝影展覽交流實為兩國文化交流重要的里程碑，面對立陶宛國家美術館所策劃展出之經典攝影作品，國立臺灣美術館與國家攝影文化中心也攜手推出同樣以兩館館藏為主的當代攝影藝術展與之對話。

臺灣當代藝術在1990年代達到一波關於認同議題的高峰，許多藝術家紛紛以本土語彙重新探討歷史與認同，也因各種自由的、現代的觀念與資訊引入，對於所謂「認同」的理解也獲得解放，不再拘泥於民族國家的前現代認同，而有更多關於性別的、土地的、家庭的，與自我認同等討論面向的作品出現。這次由國美館所策畫的《覆寫真實：臺灣當代攝影中的檔案與認同》，即以「認同」作為核心命題，邀集了國內不同世代但同樣雋永且深刻的作品，從檔案之為創作媒介與意識的角度，拆解且向國人展示關於認同議題的方方面面。

展題中的「覆寫」精準地道出認同意識往往經歷多次被覆蓋、抹除，或重新書寫的動態發展模式；然而，另一方面，它也因此提供給藝術創作許多創造力介入的空間，讓我們得以透過藝術家的實踐來揭除披覆在認同上的層層面紗。臺灣攝影的典藏與研究，也是文化部重要的使命，隨著國家攝影文化中心的成立，除了致力珍藏臺灣珍貴攝影作品，也期透過攝影來建構臺灣史與文化認同的多元面貌。與他國文化的交流，是歷史書寫重要的一環，唯有認識他人，方能更深刻地理解自身。相信此次臺立攝影交流展，只是起點，未來也期待有更多別開生面的展覽能呈現給國人。

中華民國文化部 部長

Minister's Foreword

Lithuania and Taiwan share historical situations comparable on many levels, and have been faced with many similar circumstances in terms of the current global situation. Moreover, during the recent COVID-19 pandemic, since Lithuania gifted Taiwan face masks and vaccines, an international friendship has been built between the two countries. This exchange exhibition project of Taiwan-Lithuania photography marks a crucial milestone in the cultural exchange between the two nations. While the Lithuanian National Museum of Art presents a photography exhibition of its classic photographic works, the National Taiwan Museum of Fine Arts (NTMoFA) and the National Center of Photography and Images (NCPI) have also collaborated to initiate a dialogue with the Lithuanian photography exhibition by presenting a contemporary photography art exhibition featuring the collections of the two institutions.

In the 1990s, Taiwanese contemporary art reached a peak in terms of discussing the topic of identity, and a lot of artists began employing local vocabularies to re-explore issues of history and identity. Furthermore, after different ideas and information about freedom and modernity were introduced into Taiwan, people's understanding of identity has become free as well, being liberated from the confinement of the pre-modern national identity and embracing multifaceted discourses about gender, land, family, and self-identity. Curated by the NTMoFA, *Covered Reality: Archival Orientation and Identity in Taiwanese Contemporary Photography* centers on the topic of identity and gathers different generations of artists and their works, which are equally enduring and deeply meaningful. The exhibition views archives as a creative medium and an embodiment of consciousness to deconstruct and demonstrate the various aspects about the issue of identity.

The term "covered" in the exhibition title points incisively to the dynamic development of identity consciousness, in which it often undergoes a process of repeated covering, erasing, or rewriting; on the other hand, such a process also offers an expansive space for creative intervention through artistic creation, enabling us to remove the multi-layered veil covering the reality of identity. To the Ministry of Culture, the acquisition and research of Taiwanese photography has always been a prioritized mission. Following the inauguration of the NCPI, the Ministry not only strives to treasure and preserve precious photographic works in Taiwan, but also expects to construct the diverse aspects of the Taiwan history and cultural identity through photography. Furthermore, cultural interactions and exchanges with other countries form a crucial part in history writing — only by knowing others can one more profoundly understand oneself. I believe that the Taiwan-Lithuania photography exchange exhibition marks just the beginning of more intriguingly refreshing exhibitions for Taiwanese people in the future.

Minister of the Ministry of Culture, R.O.C.

5

館長序

由本館所策劃的《覆寫真實：臺灣當代攝影中的檔案與認同》，意以「認同」作為主軸，對話《揭幕：尋探立陶宛攝影中的認同》展，向國人，同時也向遠方的立陶宛觀眾，呈現臺灣精彩的當代攝影發展切片。本展多數作品來自國立臺灣美術館與國家攝影文化中心珍貴的典藏，也藉此機會與立陶宛的國家美術館典藏品參照展出。在當前全體人類面對疫情、戰爭與環境變遷等困境時，藝術或許正是突破國與國之間的藩籬之有效途徑，得以沉澱苦痛並撫慰飽受磨難的人心。

對自身歷史與主體認同的認識，成為當代攝影藝術相當重要的創作脈絡，而此次《覆寫真實：臺灣當代攝影中的檔案與認同》更聚焦在以「檔案」為手法與創作意識的攝影與影像作品，能多層次地拆解認同此一多數人未曾深思的議題，多元且立體地展現藝術家的實踐。其中不乏臺灣重量級當代藝術家如陳界仁、梅丁衍、吳天章、姚瑞中等人的經典作品，而多以推動攝影史研究與論述發展的張美陵早期作品也難得展出，更有撐起攝影藝術中堅力量諸如周慶輝、黃子明、陳敬寶、楊順發與杜韻飛等人所挖掘出的另一種現實面貌。已故藝術家陳順築那令人動容的攝影裝置也不容錯過。此外，這次也邀請了四位以攝影作為創作媒介的青年世代藝術家：李立中、鄭亭亭、楊登棋與藍仲軒，皆以新穎的觀點，重新書寫自身、家族與國家的歷史。

同《揭幕：尋探立陶宛攝影中的認同》，在結束國美館場地展出後，本展亦巡展至臺灣攝影藝術重鎮的國家攝影文化中心，希望能拓及並吸引更多喜好攝影的民眾來參與這場交流盛事。因應場地的不同，展品也有所調整且展現不同的面貌。藝術將人們連結在一起，也讓臺灣與立陶宛站在一起，特別是於本展籌辦之際，全世界迎來了俄羅斯出兵烏克蘭此一令人悲憤且震驚的消息，更令人深思並相信普世的人文主義價值：和平與友誼。本展除了做為臺立文化交流的成果，也在此致敬兩國美好且深刻的國際情誼。

國立臺灣美術館 館長

Director's Foreword

Curated by the National Taiwan Museum of Fine Arts (NTMoFA), *Covered Reality: Archival Orientation and Identity in Taiwanese Contemporary Photography*, as an exchange exhibition to initiate a dialogue with *Uncoverings: the Search for Identity in Lithuanian Photography*, centers on the topic of "identity" and presents outstanding specimens from the developments of Taiwanese contemporary photography to both the Taiwanese people and the Lithuanian audience afar. Artworks featured in this exhibition are mostly from the precious collections housed by the NTMoFA and the National Center of Photography and Images (NCPI). As all humanity is currently faced with the difficulties brought on by the pandemic, wars and environmental changes, art offers indeed a helpful way to surpass barriers between countries to alleviate sufferings and console people's hearts in prolonged anguish.

The understanding of one's history and subjectivity has become a rather prominent creative context in the contemporary photography. Building on such a context, *Covered Reality: Archival Orientation and Identity in Taiwanese Contemporary Photography* further focuses on works of photography and image which utilize "archive" as the approach and creative consciousness to deconstruct, on multiple levels, the issue of identity — a topic that most people have yet given much thought about — and present diversely and three-dimensionally the practices of the featured artists. Among the showcased artworks, there are iconic works by celebrated Taiwanese contemporary artists, such as Chen Chieh-Jen, Mei Dean-E, Wu Tien-Chang, and Yao Jui-Chung.

Early and rarely exhibited works of Chang May-Ling, who devotes her career mostly to the study of photography history and the development of theoretical discourses, are shown in the exhibition as well. The exhibition also includes the backbone force of photographic art in Taiwan, namely Chou Ching-Hui, Huang Tz-Ming, Chen Chin-Pao, Yang Shun-Fa, and Tou Yun-Fei, whose works have uncovered alternative aspects of reality. Furthermore, what cannot be missed is the heart-touching photo installation by the deceased artist, Chen Shun-Chu. In addition, four artists from the young generation, who utilize photography as their creative medium, are invited to join this exhibition. They are Lee Li-Chung, Cheng Ting-Ting, Yang Teng-Chi, and Lan Chung-Hsuan, who adopt innovative perspectives to re-inscribe the histories of themselves, their families and the nation.

In concurrence with *Uncoverings: the Search for Identity in Lithuanian Photography*, this exhibition will be toured to the central hub of Taiwanese photography — the NCPI, in the hope of expanding the audience while attracting more photography enthusiasts to celebrate this grand event. Due to differences of the venues, the artworks on view will also be adjusted to focalize on dissimilar aspects. Art has the power to bring people together; and in this case, it has brought Taiwan and Lithuania together. Particularly, during the preparation of this exhibition, the world has witnessed the heart-wrenching and shocking Russian invasion in Ukraine, which has led all of us to reflect on and deepened our belief in the universal humanistic values: peace and friendship. This exhibition is not only the fruition of Taiwan-Lithuanian cultural exchange but also a tribute to the wonderful and meaningful friendship between two nations.

Liang

Director, National Taiwan Museum of Fine Arts

策展專文
Curatorial Essay

檔案總有其指派、交付的機構場所，其總具備重複
性的技術，且具有某種外部性。不存在無外部性的
檔案。

───── 德希達，1995

There is no archive without a place of consignation, without
a technique of repetition, and without a certain exteriority.
No archive without outside.

— Derrida, 1995

覆寫真實：
臺灣當代攝影中的
檔案與認同

策展人 / 賴駿杰
國立臺灣美術館 展覽組 助理研究員

I.
從認同談起

1
本文重點不在於數位與網路媒體所造成的認
同問題，為免失焦，在此不做更多闡述。

臺灣一直處於「認同」追索與確立的動態過
程，這與其複雜的歷史息息相關，而所謂官
方的、主調的「歷史」也因各方認同彼此的
差異與衝突而往往有不同面貌。雖然難以
簡單概述，但普遍而言——從國民教育的
角度來看，臺灣至少經歷了幾種不同的「歷
史」：從滿清仕紳與屯墾的前現代發展史而
來的中國歷史遺緒，到日本時代所接收的皇
民意識，再到國民黨的黨國一體之中國的遙
想，而後來到所謂本土意識的崛起，最後則
是因近期轉型正義思潮所帶來的「原民性」
與「族群多元」，主流的認同也因此多所迭
變。然而，認同雖可從各種層面與理論角度
切入，如心理學、社會學與政治學等，但不
可否認地，在「現代性」高度發展下，認同
逐漸產生了「問題」。

臺灣當代藝術在1990年代達到一波認同議題
的高峰，許多藝術家紛紛以本土語彙重新探
討「有問題的」歷史認同，也因各種自由
的、現代的觀念與資訊引入，對於所謂認同
的理解也獲得解放，不再拘泥於民族國家
的前現代認同，而有更多關於性別的、土地
的、家庭的，與自我認同等討論面向的作品
出現。2000年後，總體畫風一轉，越來越少藝
術家在其創作闡述中言及認同，彷彿認同不
再「有問題」，就像它已經真正地成為「同
一」般，再談它就是落伍、不合時宜。事實
並非如此。認同，在臺灣當前的當代藝術實
踐中，實際上被掩藏在更為聚焦且具體的創
作方法論中，例如歷史改造（歷史與政治認
同）、家庭相簿（家族認同）與LGBT（性別
認同）等，乃至於即便是普遍被認為走在前
沿的科技、數位與網路藝術中，那人機一體

的未來賽博格，或近期相當熱門的元宇宙與
NFT等議題，莫不觸及所謂認同議題。而這一
切（如果不是全部的話）皆與「檔案（與其
生成技術）」有關。[1]

II.
檔案，
與攝影的源起

在作為一門藝術之前，攝影主要用以紀實，並且做為某種證據以進行歸類、調查，與價值判斷等用途。已有眾多關於視覺文化研究與後殖民研究等領域的學者，向我們論證了攝影術的生成／發明並不總是浪漫地做為記憶與情感的捕捉與延續，而更多是與特定意識形態及權力建構緊密相依，成為從國族出發之帝國主義擴張下的技術工具。攝影因此帶有的強烈書寫性格，使其成為某種視覺敘事的複合物（complex of visual narrative），進一步被收納於國家的治理系統，而成為所謂「檔案」。檔案（archive），從字源學或一般理解來看，它都與政府／機構脫離不了關係。其本身有治理的意思，意即透過檔案以管理、整治，治理的對象可以是事件，也可以是人，或各種其他有生命、無生命之事物。在過去，文字，或各種論述是用以製作檔案的主要工具與來源；然而，自從攝影術興起之後，「可見的」檔案成為集話語與視覺之可證性為一身的「權威／真實（authority）」。

而其記錄真實的合法性除了與現代治理系統的形成有關之外，很大程度也來自於大眾媒體的推波助瀾，即「紀實攝影」的早期發展。早期紀實攝影主要刊載於大眾刊物，由大眾對於各種事物的好奇心所餵養。在臺灣，這類大眾刊物也在1980至1990年代成為回應當時社會氛圍（解嚴前、社會運動萌發的時代）的「新紀實攝影」之發表平臺，如《人間》、《新文化》與《島嶼邊緣》等刊物，而有越來越多「報導者」除了具有強烈的人文主義關懷之外，也帶有更多藝術性及美學的思考，例如本展所邀請的周慶輝與黃

2
關於臺灣紀實攝影發展與雜誌刊物之間的關係，可參考學者張世倫的《現實的探求──台灣攝影史形構考》（臺北：影言社，2021）。

3
斜體字為筆者所加。更多請參見其策展論述〈檔案熱：存於歷史與紀念碑間的攝影〉，收錄於展覽專輯《檔案熱：當代攝影中的文件使用》，（紐約：國際攝影中心，2008），本文參考為線上版本：https://sites.duke.edu/vms565s_01_f2014/files/2014/08/enwezor2008.pdf（2022/03/07瀏覽）。

4
雅克・德希達，〈檔案熱：佛洛伊德印象〉，《Diacritics》期刊，25.2（夏季號，1995），頁9-63。

子明，即在此脈絡下轉以攝影藝術家的身份持續觀察、記錄現實。[2] 更重要的是，這些一連串攝影與「論述」彼此構連而成為的「視覺記錄」，其自成自證的、眼見為憑且無須質疑的特質，讓人們自然將攝影等同於真實。在此語境下，攝影成為檔案之關鍵即在於「治理」的有效性：它可能被帶入更多的科學方法（某種歸類、保存的客觀技術），也可能是與大眾輿論共生的話語論述，更多的時候是權威機構的承認。隨著現代性的轉進，做為治理「技術」的檔案一方面有著「進步主義」的信仰（方法與效率），另一方面則大量仰賴「論述」所帶來的合法性，與其共同指向的治理系統。

檔案往往是輕薄的文件、書信，或照片，但其乘載的歷史意義卻有如泰山之重，因此為數眾多的當代藝術家在其實踐中導入各類型的檔案，試圖重新書寫歷史（或者，故事）。已故的知名策展人奧奎·恩維佐（Okwui Enwezor，1963-2019）在其影響深遠的攝影與影像之策展實踐《檔案熱：當代攝影中的文件使用》中，就闡述了檔案與時間的緊密關係。他引用了傅柯對檔案的觀點，認為當代藝術家有著「記憶」過去的「強烈欲望（burning desire）」，而將「做為『紀念碑（monument）』的過去」轉化為「*現時的*『檔案』」。[3] 換言之，精準地講，這些藝術家「以檔案做為方法」而重新建構、書寫，或者豎立的，是某種時間的紀念碑，它收束著人們的記憶與認同，不僅可能存在於機構或官方資料庫裡，更應該存在於特定群體的精神遺產中。恩維佐的「檔案熱」主要引用、承襲了哲學家德希達（Jacques Derrida，1930-2004）之同名著作《檔案熱》（*Archive Fever*，1995）中對於檔案的理解。德希達從字源學的脈絡切入，認為「檔案」本身具有其兩面性：「起始（commencement）」與「命令（commandment）」，直指檔案、時間與治理之間，不可分割的原生關係。[4] 然而，這裡的起始也有兩層意義，它首先指的是檔案對於過去即緣起的記錄，但它另一方面也指向在成為檔案當下才開始之真正的「解放」——思想的與記憶的。

III.
檔案、認同，
與真實

也正是其與時間／歷史之間的關係，以及其所保存或建構的「真實」，檔案成為「認同」所賴以定錨的重要關鍵之一。作為一同樣複雜多義的辭，認同也與「真實」息息相關，對於什麼是真實、可信任者之追索過程，就是所謂認同。談認同無法不去認識歷史；然而，認識歷史還不夠，本展所邀請之不同世代的藝術家們，更以攝影與延伸技術重新「檔案化」他／她們所理解的「現時／現實」，呈現出彼此相異的認同線索。將本展幾個重點思考串連起來的關鍵即為「時間」。只是，此謂時間或可理解為某種潛在的、潛行於檔案下的線索，它不見得指向過去，而更應該是直指「當下」的現時／現實，隨時都可能衝破我們所以為的真實。誠如攝影學者阿祖蕾（Ariella Azoulay，1962-）所言，攝影之為檔案之所以緊密地與過去連結，實來自於帝國主義對於「（過去）歷史」的解釋之獨有，是一種權力延伸與擴張的機制；反過來說，若將其視為當下分雜、民主且多元的異質與分裂之時間／歷史，或許才能真正地擾動僵化且同一的歷史與認同。[5]

相當弔詭地，認同之所以成形且有意義，即在於它的「不同」，就跟「真實」一樣，是不斷變動且值得懷疑的。這體現在許多方面，例如：認同真實的自己（如性別／自我認同），認同真實的歷史（如家族／國族認同），又或者更為抽象且與文化資本不可脫離的，對於社會真實的認同（如階級／社群認同）。某種層面上，「檔案」與「認同」在方法上亦可類比也相當近似，兩者皆為一系列命名、歸類、演繹，而後再次返復的機

5
同註2，頁23-24。

制與過程。沒有真正意義下的穩定（不需懷疑的）檔案，也沒有固著且同一的認同。

檔案（與其治理）不會是中性的；從蒐集的對象、建檔的方法，到最後的使用，都帶有明確的目的與意識形態。而攝影為檔案所賦予的「在場」證性，即對於「現時／現實」之證詞，則強化了檔案治理的完備與合法性。即便是相對私人的家族檔案，也是家族成員之間對於共同歷史與在場的記憶認同；或者，亦為前述所言對於時間的紀念碑之爭奪與詮釋。此「在場」有時不僅關係到個人與家族的認同追索，許多時候也以另一種面貌與路徑而連動於整體的國家與社會變化。隨著各地對於認同的解放（多元族群與性別多元）、歷史意識的重新建立（轉型正義），以及對權威（國家機器的壓迫）的批判等，藝術世界掀起一股檔案熱，越來越多藝術家開始對檔案與其所包裹、允諾的「認同」感到焦慮，而重新展開探詢與質疑。攝影與檔案不可分的原生關係，也讓檔案使用或檔案導向成為了許多攝影藝術家的創作方法，進而重新書寫現時的當下，以及過去的歷史。

作為與立陶宛國家美術館所策劃的《揭幕：尋探立陶宛攝影中的認同》之對話展，本展並不意以編年或時序作為展覽呈現的軸線，相反地，本展將緊扣「認同」之為共同的核心命題（同時也是兩國面臨的相似困境），集結「檔案之為方法」、「反檔案」、「再檔案」，與「檔案的歷史編纂學」等創作方法與意識的攝影藝術作品，展開不同面向的認同追索。如果紀實攝影為的是揭露（uncover）真實，那檔案導向就像是以「覆蓋（cover）」作為方法來重新書寫真實；覆蓋，一方面所欲表達的是如同檔案機制一般，將事物歸檔、命名（也同時指認，identify）與保存（protect），另一方面，藝術家們又再次地以其藝術實踐來報導（cover）這些被掩蓋的事物。於此同時，「認同」也像是披覆上層層面紗般，多重，且總是逃逸的「真實」。

IV.
檔案之為方法

6

劉紀蕙，〈「現代性」的視覺詮釋：陳界仁
的歷史肢解與死亡鈍感〉。《中外文學》
356期（2002.1）。頁45-82。本文參照為網路
版：https://www.srcs.nctu.edu.tw/joyceliu/mworks/
mw-interart/TaiwanArt/ChenChiehJen'sGaze.htm#_
edn5。2021/01/13瀏覽。

「檔案之為方法」不是一個嚴謹的分類，甚至也不是子題。它更像一種指導性的論述線索，用以起始本展的視覺路徑。1990年代因為數位攝影與數位影像編修技術的興起，藝術家如陳界仁、吳天章、梅丁衍與張美陵等人，挪用過去的歷史文件與檔案做為創作母題，不約而同地召喚出某種「恐怖的」主體幽靈性。吳天章比較不同，他挪用的是由攝影師劉振祥為侯孝賢電影《戀戀風塵》（1986）所拍攝的知名劇照，談的是個人在整體社會情境中格格不入，一種被排斥的（小）主體敘事。值得注意的是，吳天章作品中那近乎飄在空中如鬼魅般的丑角，攜手走向的是虛無之前方，加上滿佈於邊框的人造花與俗艷的閃亮配色，都充斥著濃烈的不適與死亡氣息。《戀戀風塵》中那令人不安的「場景」，對吳天章來說，或許才是臺灣歷史的真實面貌：中斷的、流放的、與鬼魅的。就視覺上的鬼魅或幽靈形象來討論，梅丁衍的《台灣西打》（2008-）系列則可能更充分地召喚出所謂「舊的」人／事／物，即藝術家所致力處理的「鄉愁」。梅丁衍蒐集並選用了無從查找來源的日殖時期與國民政府來臺初期之老照片，透過數位技術重新虛構、編造出幽靈的鄉愁場景：正因為無名，所以幽靈；正因無邊，所以鄉愁。

與吳天章對於檔案的「搭建」與「挪用」類似，張美陵的《重返乙未一八九五》系列（1995）也透過場景搭建與翻攝手法，重訪1895年乙未戰爭的歷史，試圖使觀者在戰爭與恐怖的場景中，重新思考臺灣在此歷史脈絡下的主體定位。陳界仁的作品，相較之下，或許更直接地把惡夢的過去從檔案中搬至觀者眼前，逼使我們凝視恐怖。然而，這

裡的恐怖更像是一種掩飾，就像學者劉紀蕙於〈「現代性」的視覺詮釋：陳界仁的歷史肢解與死亡鈍感〉一文更進一步延伸指出，「（…）此『恐怖』美學與揭露，顯示，發現被遮蓋的現實有關。」她接續喬治·巴岱耶（Georges Bataille）的觀點，指出陳界仁的恐怖影像背後所遮蓋之現實，也就是歷史所欲遮蓋的現實——即歷史所施展的「酷刑」，用以遮蔽我們所能感知的「真實」。[6]

V.
反檔案，
或檔案的無政府主義

德希達將檔案同佛洛伊德精神分析中的「死亡驅力」連結在一起，在他的理解中，檔案化的過程中總有雙重的矛盾性，即保存/記憶的同時，也同時朝向「遺忘」。因此，檔案化即意謂著「註定被遺忘」。記憶藉由「檔案化」而被銘刻、儲存於所謂「內在的外部」媒介中，而使外部得以介入記憶的內在，進而使「記憶的真實」成為不可能。[7]死亡驅力，意謂著朝向最終的「解構」與「抹殺」，如同德希達以「檔案熱（fever，指的是如同惡疾般而無法揮去）」所暗示的，檔案不斷地且狂熱地重複其自身，直到破壞且遺忘自身。他稱這股無可避免的驅力為「反檔案的（anarchivic）」，即抵抗、推翻檔案自身的檔案。[8]

藝術家陳順築的檔案使用即帶有很強烈的死亡意象，並且用了「建築性」語言－磁磚與盒子，意圖「建造」關於其家族的記憶之檔案庫。以家族老照片做為主要媒介，保證了記憶的延伸可以被辨識，又，所謂的「外部媒介」如上述之磁磚，它本身則與攝影影像形成衝突性對比：影像之熱 v.s. 媒介之冷，這些，我認為皆是對於記憶真實性的「反檔案之補充」。實際上，藝術家本人對於記憶之真實性有很清楚的自覺，記憶是值得不斷懷疑的一種持續性檔案化工程。死亡意象，毫不遮掩地成為這次展出的《家族黑盒子》之核心概念，它是陳順築為其父親所舉辦的私人儀式，[9]參與人員只有他自己與已逝的父親。在盒子裡，只有他們兩人所展開的私密對話，透過撿選父親所拍攝的老照片，連同其所編攝之照片與家居配置拼組在那小小的盒子裡，以填補記憶中的父親、記憶中的家

7
同註4，頁13-14。

8
參見吳建亨，〈一種正義，各自表述：時間、檔案、書寫〉，《共再生的記憶─重建臺灣藝術史學術研討會論文集》，臺中：國立臺灣美術館，2018。

9
關於盒子所召喚的「儀式性」與父子間私密對話的解讀，可參見林奇伯，〈人子走不完的歸鄉路──當代藝術家陳順築〉，《台灣光華雜誌》（2011.9），本文所參照為網路版：https://www.taiwan-panorama.com.tw/Articles/Details?Guid=3d5ff681-25e4-4f42-81c7-97b73d085fbd（2022.04.09瀏覽）。

Seeking for and establishing "identity" has been a long-withstanding dynamic process for Taiwan given our complex history. The so-called official and dominant narrative of our "history" has often taken on various faces due to the different factions accommodating conflicts that are reflective in nature. Despite the difficulty in providing a brief overview, generally speaking, from the perspective of 12-year Basic Education, Taiwan has experienced at least several different versions of "historical consciousness", ranging from the pre-modern development of the Manchu gentry and tunken (military settlement and land reclamation) from the Greater China mentality, the Japanized self-awareness assimilated during the time under Japanese rule, the Kuomintang's reminisce of an united party and state, the rise of the so-called local consciousness, and finally to the "Indigeneity" and "Ethnic Diversity" brought about by the growing concept of transitional justice, leading to inexhaustible adaptations in mainstream identity. However, although the discourse of identity can be approached from various levels and theoretical perspectives, such as psychology, sociology and political science, it is undeniable that under the development of "high modernity", identity has gradually created "problems".

The discourse of identity reached a peak in the Taiwanese contemporary art scene in the 1990s, with a number of artists endeavouring to explore afresh the "problematic" identity constructed in the course of history in local vocabulary. Together with the introduction of various liberal and modern concepts and information, understanding of the so-called identity has been liberated and is no longer bound to the premodern identity of the nation-state. More works on gender, land, family, and self-identity have therefore emerged. There has been a general shift in the art world after 2000, with fewer artists examining identity in their artworks as if it is no longer "problematic" and as if a real "identity" has been consolidated and accepted. In this case, to talk about it further seems outdated and irrelevant. But this is hardly the case. In Taiwan's current contemporary art practice, identity is indeed embedded in more focused and defined creative methodologies, such as the reconstruction of history (historical and political identity), family albums (family identity) in adoption and approaches in connection with LGBT issues (gender identity). Even in areas like technology-inspired, digital and internet art, which are generally considered to be at the forefront of the industry, the future cyborg of human-machine hybrid or the recent rise of the metaverse and NFT, all, without exception, touch on the issue of identity. These practices, if not all, pertain to "archiving" (and the archival technologies that generate). [1]

II.
Archiving,
and the Origin of Photography

Before photography being considered an art form, it is mainly used for documentation and as a kind of evidence for categorisation, research, and value judgement. Scholars in the fields of visual culture and postcolonial studies have argued that the invention of photography was not always a romanticised idea of capturing and perpetuating memories and emotions, but was more closely related to specific ideologies and the gaining of power. It was a tool for the expansion of imperialism from a national perspective. Photography possesses a distinct quality of writing, thus making it a certain complex of visual narrative that is further incorporated into the system of governance of the state and becomes the so-called "archive". The archive, in an etymological or even a general understanding, is inextricably linked to the government/institution. It means to govern; it is to manage and administer through archiving. Events, people, things that are animate or inanimate can be the subject to be governed. In the past, written words or indeed, different forms of discourse were the main tool and source of the archives; however, since the rise of photography, the "visible" archive has become an "authority/truth" that combines discourse and visual verifiability.

The legitimacy of documenting reality is not only related to the formation of a modern governance system, but is also largely fuelled by the mass media, forming the "documentary photography". Early documentary photography was mainly found in publications of the mass media, satisfying the curiosity of the public about various things, and sometimes entertaining people hunting for novelty. In Taiwan, these publications also became a platform for the showcasing of the "New Documentary Photography". It is a genre that responds to the social atmosphere defined by the emergence of social movements before the lifting of the Martial Law in the 1980s and 1990s. Examples of these publications are *Ren Jian* (the human world) *Magazine*, *The New Culture*, and *Isle Margin*. More and more "journalists" who, in addition to their strong humanistic concerns, brought in artistic and aesthetic considerations. Chou

2
For more information on the relationship between the development of documentary photography in Taiwan and publications, please refer to Chang Shih-Lun's book *Reclaiming Reality: On the Historical Formation of Taiwanese Photography* (Taipei: Voices of Photography, 2021).

3
Text in italics is added by the writer. See the curatorial essay *Archive Fever: Photography between History and the Monument* from exhibition catalogue *Archive Fever: Uses of the Document in Contemporary Art* (New York: International Center of Photography, 2008). This essay referenced the online version URL: https://sites.duke.edu/vms565s_01_f2014/files/2014/08/enwezor2008.pdf (visited on 2022/03/07).

4
Jacques Derrida, *Archive Fever: A Freudian Impression*, *Diacritics* 25.2 (Summer, 1995), pp.9-63.

Ching-Hui and Huang Tz-Ming, who are featured in the exhibition, have continued to observe and document reality as artist-photographers under this context.[2] More importantly, these series of photographs and "discourses" are interconnected with each other to form a "visual archive" whose self-formed and self-evident, unquestionable and seeing-is-believing quality allow people to naturally equate photography with reality. In this context, the key to photography becoming an archive lies in the validity of "governance"; it is how more scientific methods such as certain objective techniques of categorisation or preservation could be introduced; it is a discursive discourse in sync with public opinion, or how it is the recognition of an authoritative body. As modernity progresses, the archive serving as a "technique" of governance embraces the "progressivist" belief that celebrates method and efficiency on the one hand, and, on the other, with its heavy reliance on the legitimacy of "discourse", points towards a new system of "governing".

Archives are often paper-thin objects such as documents, letters, or photographs, but their historical significance is momentous. Many contemporary artists are trying to rewrite history or, perhaps, stories by incorporating various types of archives into their artistic practice. In his influential curatorial practice on photography and film *Archive Fever: Uses of the Document in Contemporary Photography* (2008), the late acclaimed curator Okwui Enwezor (1963-2019) illustrated the close relationship between the archive and time. He cited Foucault's view of archiving as a contemporary artist's "burning desire" to "memorise" the past, transforming "the past 'monument'" into the "*present* 'archive'".[3] In other words, what these artists have reconstructed, written, or erected "by employing archiving as a method", to be precise, is a certain monument of time; it is a collection of memories and identities that may exist not only in institutional or official databases, but also in the spiritual heritage of a specific group of people. Enwezor's "Archive Fever" is mainly a reference to, and an inheritance from the work of the same name by philosopher Jacques Derrida (1930-2004). In *Archive Fever*, Jacques Derrida argues from an etymological approach that "archiving" itself embodies an internal contradiction and duality, namely "commencement" and "commandment". It invokes at once the inseparable relationship between archive, time, and governance; however, this commencement houses two meanings.[4] It refers to, first of all, the archive as a record of the past. It also refers, on the other hand, to the real "liberation" of thoughts and memories that begins only at the moment when these depositories of the past become archives.

III.
Archiving,
Identity, and Reality

It is also the relationship to time/history and the "truth" it preserves or constructs that makes archiving one of the fundamental anchors of "identity". Identity, as a complex and multifaceted term, is also closely related to "reality". The probing into what truth is and who to be trusted is the so-called identity. It is impossible to talk about identity without knowing history; yet, knowing history itself is not enough. Artists of different generations featured in this exhibition use photography and extended technology to "archivalise" their understanding of "present/reality", presenting divergent traces of identity. Whereas "time" is the key to connecting the various major notions in the exhibition, it is only that this "time" should be understood as some kind of submerged potential trace in the archive. It does not necessarily point to the past, but rather to the now/reality of the "present", which can break through our perceived truth at any moment. As the theorist of photography and visual culture Ariella Azoulay (1962-) argues, photography as an archive being closely linked to the past is because of the exclusivity of the imperialist interpretation of "history (of the past)", a mechanism for the extension and expansion of power. But, on the contrary, if only it was seen as a miscellaneous, democratic, diversely heterogenous, and fractured time/history of the present, would the rigid and homogeneous history and identity truly be stirred.[5]

Paradoxically as it may sound, what forms identity and makes it meaningful is how its variation, just like "reality", is fluid and doubtful. It is manifested in many ways, such as the identity of our real self (e.g. gender/self-identity), the real history (e.g. family/national identity), or, more abstractly and inevitably linked to cultural capital, identity of the social reality (e.g. class/community identity). "Archiving" and "identity" are also similar in their approaches, both being a series of mechanisms and processes of naming, categorising, interpreting and repeating. There is no such thing as a stable (undoubtful and certain) archive, nor is there a fixed and consistent identity.

[5] See Note 2, pp.23-24.

Archiving (and its governance) are never neutral; it carries a clear purpose and harbours ideologies in who they are collected from, how they are created, and ultimately how they are used. The "presence" that photography endows to the archive, that is, the testimony to the "now/reality", reinforces the integrity and legitimacy of the governance of archiving. Even family archives that are relatively more private are the identity of recollections of shared history and presence among family members or, as mentioned above, a contestation and interpretation of a monument of time. This "presence" is sometimes not only a matter of personal and family search for identity. In many cases, it is also a link to the overall national and social changes in a different light and path. With the emancipation of identities (ethnic and gender diversity), the reestablishment of historical consciousness (transitional justice), and the critique of authority (the oppression of the state apparatus), the art world in Taiwan is experiencing an archive fever. More artists are becoming anxious about archiving and the "identities" it encases and promises, prompting them to re-explore and question it. The inseparable relationship between photography and archiving has made the use of archives or the archival orientation the creative approach of many artist-photographers, in order to rewrite the present and the history of the past.

As an exhibition in dialogue with *Uncoverings: the Search for Identity in Lithuanian Photography* curated by the Lithuanian National Museum of Art, this exhibition is not intended to present Taiwanese Photography in chronological order. In contrast, it will focus on the shared core theme of "identity", a similar dilemma faced by both countries. Photography works with various approaches and perceptions like "Archiving as a Method", "Anarchive", "Re-archiving", and "Historiography of Archiving" are brought together to explore different aspects of identity. If the purpose of documentary photography is to uncover the truth, the orientation of archives is akin to using "cover" as a method to rewrite the truth. To cover, on the one hand, manifests itself in filing, naming, identifying, and protecting, just like the mechanism of archiving. On the other hand, the artists "cover" these concealed things and incidents again with their artistic practices. Meanwhile, "identity" is veiled, in multiple layers, just like the "reality" which is also a fugitive that can never come to light.

IV.
Archiving as a Method

6

Joyce C. H. Liu, *Chen Chieh-jen's Aesthetic of Horror and his Bodily Memories of History, Chung Wai Literary* 356 (2002.1), pp. 45-82. This article referenced the online version of URL: https://www.srcs.nctu.edu.tw/joyceliu/mworks/mw-interart/TaiwanArt/ChenChiehJen'sGaze.htm#_edn5 (visited on 2021/01/13).

"Archiving as a Method" is not a scrupulous classification, nor is it even a subtopic; it is more of a guiding trace of narrative to blaze the visual path of the exhibition. In the 1990s, with the rise of digital photography and digital video editing, some artists began to use historical documents and archives as the subject of their works, conjuring a certain "horror" in the spectral nature of the subject. The artists used digital technology to reconstruct and recreate a nostalgic scene of the phantom. Wu Tien-Chang is different in that he appropriates the famous stills taken by photographer Liu Chen-Hsiang for Hou Hsiao-Hsien's film work *Dust in the Wind* (1986), which deal with the (petit) subject narrative of the individual as an outcast in the overall social context. It is worth noting that the almost ghostly clown-like characters in Wu's work, who are floating in the air, are forging ahead hand in hand towards nothingness. Together with the tacky glittering palette and artificial flowers covering the edge, the artwork permeates a strong sense of unpleasantness and death. The disturbing "scenes" in *Dust in the Wind* are perhaps, for Wu, the true face of Taiwan's history. A past that was interrupted, exiled and haunted. In terms of ghosts or spectral images, Mei Dean-E's series *Taiwan Cider* (2008-16) may evoke in a more powerful way the so-called "old" people and things, in other words, the "nostalgia" that the artist strives to address. With digital technology and by collecting and using untraceable old photographs from the Japanese colonial period and the early days of the Kuomintang government's arrival in Taiwan, Mei recreates and fabricates the ghostly scenes of nostalgia. In that case, the namelessness creates the spectre and the boundlessness nostalgia.

Similar to Wu Tien-Chang's "construction" and "appropriation" of the archive, Chang May-Ling's series of *1895, Revisited* (1995) also reviews the history of the Yi-Wei War of 1895 through construction of scenes and photography of the re-enactment, inviting the audience to rethink Taiwan's subject positioning in this historical context in a scene of war and terror. Chen Chieh-Jen's work, in comparison, relocates and exposes the nightmarish past from the archives to the audience, forcing them to confront the shuddering horror. However, the said horror is more of a cover-up, as the scholar Joyce C.H. Liu further argues in her article *Chen Chieh-Jen's Aesthetic of Horror and his Bodily Memories of History*, "…this aesthetics of 'horror' is related to the revelation, the presentation and the discovery of a hidden reality." She applies and elaborates Georges Bataille's view that the reality behind Chen's photo-images of horror is the same reality that history seeks to obscure, that is, the "torture" that history inflicts, to conceal what we perceive as "truth".[6]

V.
Anarchive,
or the Anarchism
in Archiving

Derrida associates archiving with the death drive in Freudian psychoanalysis. In his understanding of archiving, there is always an internal contradiction in "archivalisation", which points to how preservation/ remembering is a simultaneous stride towards "forgetting". Archivalisation, thus, connotes being "destined to be forgotten". Memory is inscribed and stored in the "domestic outside" medium through "archivalisation", which allows the outside to intervene the interior of memory, thus making the "truth of memory" impossible.[7] The death drive implies the move towards ultimate "destruction" and effacement. Just as Derrida suggests with the term Archive Fever, with the word fever entailing a haunting malady, the archive repeats and replicates itself frantically and constantly until it destroys and forgets itself. He named this inevitable drive "anarchivic", meaning the resisting and overthrowing of the archive itself.[8]

Chen Shun-Chu's use of the archives is strongly suggestive of death and employs an "architectural" language, i.e., tiles and boxes in an attempt to "construct" an archive of his family's memories. The use of photography as the primary medium ensures that the extension of memory can be clearly identified. And perhaps as regard to the "external medium" such as the tiles mentioned above, it is in conflict with the photographic image, with the fieriness of the image being in contrast to the coldness of the medium. These are, to me, a "supplement of anarchive" to the authenticity of memory. In fact, the artist's self- awareness of the authenticity of memory is a never- ending archivalisation project that requires constant questioning. The imagery of death is unmistakably central to the concept of the exhibited artwork *Family Black Box* (1992). It is a private ritual that Chen performs for his father, involving only the two of them.[9] In the box are the father and son having an intimate conversation. Through selecting old photographs taken by his father and assembling those photographs and furniture in the small box, it fills in the memory of his father and his family and eventually reconstructing

7
See note 4. pp.13-14.

8
See Wu Chien-Heng, *One Justice, Each to Its Own: Time, Archive, and Writing, The Renaissance of Cultural Memory: Collected Papers of the Symposium on Reconstructing Art Histories in Taiwan* (Taichung: National Taiwan Museum of Fine Arts, 2018).

9
For the interpretation of "the ritual" evoked by the box and the intimate dialogue between father and son, see Eric Lin (Lin Chi-Bo), *The Long Road Home - Contemporary Artist Chen Shun-Chu, Taiwan Panorama* (2011.9). This article referenced the online version of URL: https://www.taiwan-panorama.com.tw/Articles/Details?Guid=3d5ff681-25e4-4f42-81c7-97b73d085fbd (visited on 2022/04/09).

his present self. The *Family Black Box* is not only, as he puts it, a ritual for the repose of his father, but also ceaseless project of self-identification.

Yang Teng-Chi's *Father's Video Tapes* (2011-) series also begins with a dialogue between his father and himself, but his complex and insecure upbringing imbues these conversations with a sense of redemption. At the time of oppression, his gay desire is not only a social "taboo"; it is first and foremost a family taboo. Therefore, *Father's Video Tapes* is not only a redemption of his father (understanding and forgiveness), but also a redemption of the self (revelation) and, of course, an "archivalisation" of self-identity. Using his father's private archives as a starting point, Yang re-dismantles and contemplates the "history/father" that is significant to him, and follows its footsteps, going back in time to the starting point of his own personal history to understand himself better. Without the liberation of gender identity, this kind of identity and use of archives would have been unimaginable in the old times for Taiwanese photography/contemporary art. On the other hand, the father's "dementia" also makes history/time untrustworthy, but this is already, perhaps, closer to the true face of history; the timeline between the artist and his father does not match up, which also at the same time suggests the multi-linear flow of history. This series of works is not merely about the relationship between the artist and his "history", but also, to many of us, about the imagination of identity in relation to nation and patriarchy.

The state, or the government, is the main subject of the anarchival creative approach, and the subject of resistance for artist Yang Shun-Fa. He has documented the archival photographs of the Hong Mao Gan in Kaohsiung city that were "erased from the archives". The archive of the families and villages of the people resided in Hong Mao Gan, which then belonged to nowhere because the place were forcibly demolished, are preserved in these magical and surreal images. In a way, the series *Home and Rootless* (2005-2008) is undoubtedly a resistance against the state and the government; however, paradoxically, in the midst of archiving, the memories of people in Hong Mao Gan are also unfolding their destiny of being forgotten.

VI.
Re-archiving

In this exhibition, "Re-archiving" is perhaps the most simple and direct, but also the most powerful. The "evil of the archive" brought about by photography has become an important tool in the construction of power in the state and society, and "how to archivalise" (in this case, mainly the "archive of images", i.e. photography) determines the position of the archived subject in the structure of power. Artists such as Chou Ching-Hui, Huang Tz-Ming, Chen Chin-Pao, and Tou Yun-Fei have, respectively, re-archived the neglected, the forgotten, and the "in-betweens" through different narrative structures. In the series *Out of the Shadows* (1991-1993), Chou gives a careful and respectful account of the neglected and stigmatised lepers, in which not only their names but also the meaning of their behaviours (lives) are confronted. They are no longer excluded or anonymous figures waiting to die. The veterans in Huang's series *Anti-communist Tattoo on Prisoners-of-war from the Korean War* (2013) are veritably men who were being forgotten in the archives, and their identity is not only paradoxical but also embarrassing. These veterans were prisoners of war sent by their homeland (China) to fight in the Korean War and came to Taiwan because of different historical situations. Their identities engraved (tattooed) are thus invalidated. The artist's "re-archiving" cannot really resolve the situation of these "chivalrous people", but it can remind them, and the audience, that the most important primary identity is not that of their countries, but that of themselves.

Chen Ching-Pao's *Betel Nut Beauties* series (1996) gains and gives ,through "re-archiving", respect to women who have been "sexually stigmatised" for a long time, and finally being treated as a "normal person". The betel nut beauties and their lives are no longer perceived through the lens of sexual curiosity or objectification. Family and parenting should not be labels of class division, but rather, universal values of human rights and free will. Unlike anarchive, re-archiving is more direct and to the core. Just like Tou's *Ancestral Portraits: the Future* (2018-2021) uses an ID-photo-like approach to document the second generation of

immigrants in Taiwan. These images are thus recognised and acknowledged. The liberation of "naming" hence allows the "outsider" to be contained and included and become "one of us".

Although it is not an individual's retrospect, Yao Jui-Chung + Lost Society Document + Sandy Hsiu-Chih Lo's *Mirage: Disused Public Property in Taiwan* (2010-2019) is a re-archivalisation of "architecture (that are excluded from the archive)". The subjects visited are not so much forgotten in the archives as they are covered by them. What the government would like most is for them not to be revealed. Through the artist's re-archiving, it is hoped that these "intact ruins (white elephants, known as "Mosquito Hall" in Taiwan)" will get the attention and visitors they are able to accommodate and be put back on track.

VII.
Historiography of Archiving

In contrast to the previous approach of transforming and reconstructing archives, this group of artists not only directly engage with history through aesthetic practices, but they also recompile history from a different perspective. Historiography, as the name implies, is the history of history, and its importance lies in the unique perspective of the "method of compilation". Lee Li-Chung returns to the history of aerial warfare from the perspective of war pigeons, and responds to the reversed tendency of archiving. *The Memo of Formosa Air Battle* (2020) uses an "animal perspective" in an attempt to subvert the human perspective and the history written by man. Starting from the story of a Taiwanese teenage worker who is also a nobody, the artist reconnects the teenage worker with the aircraft, and the aircraft with the military pigeons, and reclaims an important place for the culture of pigeon racing in the culture of the common people of Taiwan. Homing pigeons and pigeon racing not only explore the historical issues of Taiwan from the period of Japanese colonial rule to the post-war period, it also serves as an emotional attachment for Lee to project his self-identity.

Through used stamps and travelogue photographs, Lan Chung-Hsuan's series of *A Battlefield Is a Wishful Thinking, yet the Stamp Is a Piece of Paper* (2020-2022) and *The Wall* (2022) once again "authenticate" the historical and geographical gap between the battlefield of Kinmen and Taiwan, and between the battlefield of Kinmen and the Berlin Wall. What remains are the foregone begonia and the deep and unshakable anguish soddened in nostalgia. The hero is dead. *Godness*, within the series uses the Latin letter θ, a symbolic reference to "death" in ancient Greco-Roman times, to cover the entire face of the "goddess" Teresa Tang, overflowing the image with the sense of ominousness. The death drive of archiving is shown here as a recurring cycle, as a death-driven life, a typical national belief in the trinity of party/government/religion, or in another word "immortality".

Cheng Ting-Ting's series of *Unearth Tomorrow* (2021) takes us on a journey of space and time disregarding history and boundaries, with a first-person perspective to unearth the future. The three artists make use of new, previously unappreciated, and even fictional archives to write new histories, reengaging with original narratives and plots in a supplementary manner. The archives are thus like the islands (fragments) floating in the air in Cheng's work, depending on the perspective from which we comprehend and utilise them, paving way for the past and the future to be intersected in the present. These islands are just stones. In a way they cannot be "effectively" described and archived, like a vacuum zone in history. The artist's iconographic approach, however, gives these rocks a great deal of weight, breaking the grip of historical narrative on the anonymous (and un-documentable) fragments and recompiles historical studies and its methods. By putting this series of artworks at the far end of the exhibition space, it is hoped that the audience will follow the artist's footsteps to rethink and stand firmly on these floating islands, coordinating themselves.

藝術家及作品介紹
Introduction to the Artists and Works

I.

檔案之為方法
Archiving as a Method

吳天章
WU Tien-Chang

1956年生，成長於基隆，1980年自中國文化大學美術系畢業。吳天章1980年代的創作，聚焦於歷史及政治，1990年代後，他開始融合俗民文化及生活經驗，以戲謔矯飾的黑色幽默，將日常物件結合影像，構築成聳動的奇觀，其應用臺灣俗媚視覺現象的特色，使其被稱為「臺客藝術家」。在2000年後，吳天章將符號化的詭譎美學作品，進一步發展成互動裝置，編排式的攝影，呈現既復古又現代的蒙太奇風格。吳天章的參展經歷豐富，除兩度參與《義大利威尼斯雙年展》（1997、2015），也多次參與《台灣美術雙年展》、《臺北雙年展》、《亞太三年展》等指標性藝術展覽。

Born in 1956 and grew up in Keelung, Wu Tien-Cheng graduated from the Department of Fine Arts, Chinese Culture University in 1980. His works of the 1980s revolve around history and politics. After the 1990s, he started integrating folk culture and life experience with a black sense of playful, pretentious humor, and combined everyday objects with photographic images to construct sensational spectacles. His use of the kitsch visual phenomenon, which is characteristic of Taiwanese, has earned him the reputation of "Tai-Ke artist". After 2000, Wu has further developed his symbolized, uncanny aesthetics into interactive installations combined with staged photography, demonstrating a montage style that is rather retro and modern at the same time. Wu's work has been exhibited extensively. In addition to being featured twice in the *Venice Biennale* (1997; 2015), he has participated in iconic art events several times, including the *Taiwan Biennial*, the *Taipei Biennial*, and the *Asia Pacific Triennial* of Contemporary Art.

春宵夢 II
Dream of the Past Eva II

〈春宵夢 II〉是吳天章介於1990年代至2000年之間，充滿廉價矯飾的複合媒材作品過渡到編排式攝影裝置的指標性作品。〈春宵夢 II〉看似在拍攝一位穿著早期中式服搭配西式百褶裙的女性，雙手摀在胸口，金粉邊框的墨鏡遮住了彷彿鋪滿白粉底的臉，只能從肢體感受人物的不安。而動態裝置的設計，觀眾可藉由踏板開啟作品，彷彿古早味歌廳的音樂響起，配合聖誕燈泡的閃爍及聚光燈在畫面中的不斷變化，彷彿進入劇場般，觀眾的視覺被光線引導，身不由己地凝視著她，加深了主／客體間的侵略及對立關係。（編寫／林學敏，參考自國立臺灣美術館典藏詮釋資料。）

Created between the 1990s and the year of 2000, *Dream of the Past Eva II* is a representative work of Wu, which shows his transition from works made of inexpensive, kitsch mixed media to installations of staged photography. *Dream of the Past Eva II* showcases a woman wearing an early Chinese-style top with a Western-styled pleated skirt. With both her hands covering her chest and a pair of pinkish, gilded sunglasses hiding her whitewashed face, viewers can only detect the figure's uneasiness from her body language. The installation is designed as a kinetic device. When viewers step on a paddle, the work will be initiated to play music reminiscent of cabarets in the early days, accompanied with twinkling Christmas lights and changing spotlighting in the image. Viewers are consequently immersed in a theater-like atmosphere, with their eyes being guided by the light to gaze unknowingly at the woman in the image, thus deepening the aggressive relationship and opposition between the subject and the object. (Mandarin text redacted by LIN Hsieh-Min. Refer to the National Taiwan Museum of Fine Arts Collection database.)

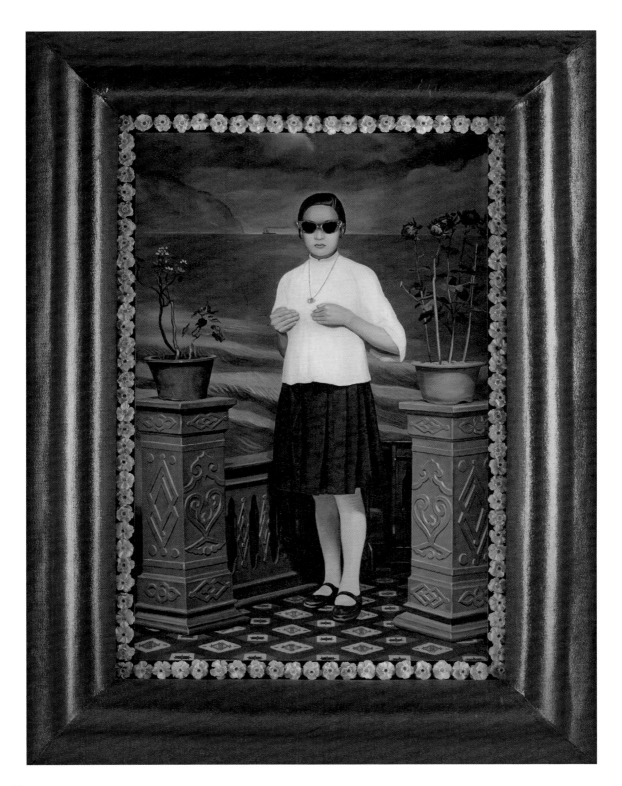

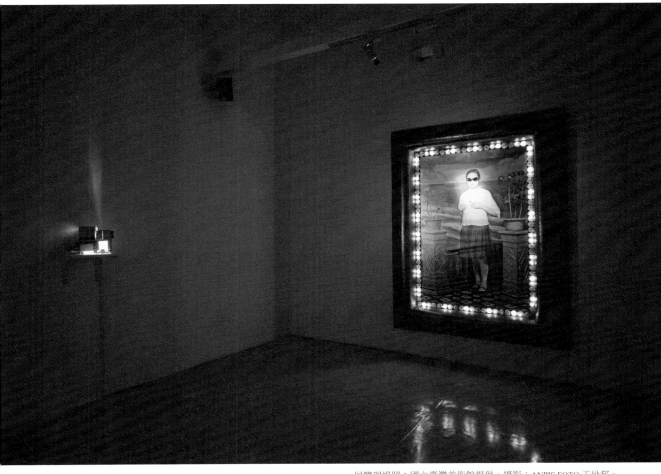

〈春宵夢 II〉
1995。相紙、人造皮、人造花、亮珠、裝置。209.5×160×20公分（含框）。國立臺灣美術館典藏。

Dream of the Past Eva II
1995. Artificial leather, artificial flowers, bugle beads on digital print, installation. 209.5×160×20 cm (framed).
Collection of the National Taiwan Museum of Fine Arts.

戀戀紅塵
Attachment to the Mundane World

〈戀戀紅塵〉使用侯孝賢導演1986年的電影《戀戀風塵》劇照為基底，一反電影中清透靈性的視覺風格，吳天章使用俗豔誇張的紅色錫箔及廉價塑料感的人造花裝飾外框，背景畫上彷彿霓虹一般漸層的紅黃光影，並用向日葵、紅領結等物件，蒙住了劇中人物的眼，影像中男子口中塞著白色圓球，看似面無表情卻讓人感受到人物臉部被強行扭曲的痛苦，在無法直接觀察劇中人物的情緒下，整件作品依然呈現出略帶不安且陰鬱的氣氛。（編寫／林學敏，參考自國立臺灣美術館典藏詮釋資料。）

Attachment to the Mundane World builds upon a scene of *Dust in the Wind*, Hou Hsiao-Hsien's movie in 1986. Contrary to the clear, light visual style of the original scene, Wu Tien-Chang utilizes gaudy, over-the-top red tin foil and cheap, plastic flowers to decorate the frame, with a red-yellow gradient shade spans the background of the image. The eyes of the characters from the movie are covered by a sunflower and a red bowtie respectively. The man in the image is gagged by a white ball. Though the figures' faces are expressionless, viewers could to feel their discomfort as shown by their distorted faces. While viewers cannot directly perceive the emotions of the characters, the overall work is still shrouded in a rather unsettling, gloomy atmosphere. (Mandarin text redacted by LIN Hsieh-Min. Refer to the National Taiwan Museum of Fine Arts Collection database.)

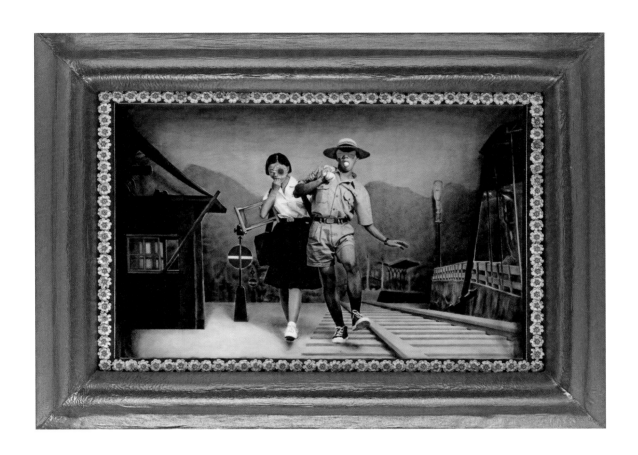

〈戀戀紅塵〉
1997。油彩、相紙、亮片、人造花、金蔥布。160×220×13公分（含框）。國立臺灣美術館典藏。

Attachment to the Mundane World
1997. Oil painting on digital print, sequins, artificial flowers, metallic woven fabric. 160×220×13 cm (framed).
Collection of the National Taiwan Museum of Fine Arts.

張美陵
CHANG May-Ling

1956年生於臺北，畢業於美國哥倫比亞大學教育學院，人文與藝術學系，藝術教育博士。2015至2016年間擔任「攝影文化資源調查計畫」主持人。現為攝影藝術推廣社團「去攝影」主持人、藝術家、策展人、教師、政府文化機構的咨詢委員、典藏委員、評審與評鑑委員。長期關注於攝影藝術研究教育推廣，致力推動成立「國家攝影文化中心」。曾於臺北攝影藝廊舉辦《重訪乙未1895》個展（1995），臺北市立美術館《重複與遺忘》個展（1998），帝門藝術教育基金會《你哪裡不舒服》個展（2000），並參與臺北當代藝術館20週年回顧展《你們家有什麼東西可以拿到美術館展覽？2001+2021》（2021）。

Born in 1956, Taipei. She holds an Ed.D in Art Education from the Department of Arts and Humanities, Teachers College, Columbia University. She is the chair of the "Photography Cultural Resource Investigation Project" from 2015 to 2016, and is now the head of "go/de-photography," a society that promotes the art of photography. Chang plays many roles in life: she is an artist, curator, and teacher, as well as a member in various consultation, collection, and evaluation committees in governmental cultural institutions. She has long dedicated her time to the research, education, and promotion of photography, and has been a driving force in the establishment of the National Center of Photography and Images. Her solo exhibitions include *1895, Revisited* at Taipei Photo Gallery (1995), *Repetition and Forgetting* at the Taipei Fine Arts Museum (1998), and *Makuda Sun Saetju: Where Don't You Feel Good?* at Dimension Endowment of Art (2000). She is also featured in the 20th anniversary exhibition of the Museum of Contemporary Art, Taipei, titled *Is There Anything in Your Family that Can Be Exhibited in the Art Museum? 2001+2021* (2021).

《重返乙未一八九五》系列
1895, Revisited Series

1895年的臺灣人民以粗劣武器與現代化的日本軍隊對抗，他們明知敵我懸殊，卻仍知其不可為而為之。懷著「願人人戰死而失臺，絕不願拱手而讓臺」的精神，力拼死戰。依據馬關條約，臺灣人民於兩年內若不願作日本國民可自由遷移出境。然而這些抗日臺民的家園就在臺灣，無路可退，寧願選擇背水一戰，與臺灣共存亡。為了抗日，他們散盡家財，甚至犧牲生命。

由於我方並無當時的軍事紀錄照片，而日軍的軍事紀錄目的不外乎誇示其佔領臺灣的勝利戰果。這百年來，日方的乙未征臺紀錄，因有其各自宣傳術的意圖，毋寧是一種匱乏，由於認知的差異與歷史記憶的消失，使得歷史真實的呈現變成疑難重重。乙未戰事的攝影紀錄不等同於真實而是一種立場的詮釋，歷史照片不是客觀事實而是權力建構。

張美陵用虛構場景的方式來再現乙未戰事，以想像的真實突破時空限制，回到百年的歷史之中。先將日軍的軍事紀錄翻拍成幻燈片，再將幻燈片投影在牆上，在投影的影像前用各種材料，建構出類似戰爭的場景。這些虛擬場景有山有河，有武器有殘骸，有傾城有廢墟，以象徵隱喻再現臺灣從北到南各處的戰場，以及戰況的火光煙硝和動盪狼藉；暗示抗日義軍的奮勇精神與生命光輝，也暗示他們的憤怒、掙扎、無助、哀戚的情境。（藝術家提供）

The year of 1895 witnessed Taiwanese people's fighting against the modernized Japanese army with crude weapons. Despite the disparity between the force of the enemy and that of their own, the Taiwanese people still persisted in what they knew was a mission doomed for failure. With the spirit of "rather losing Taiwan by dying in battlefield than giving Taiwan away without a fight," they fought bravely until the last moment of their lives. According to the Treaty of Shimomoseki, Taiwanese people who were not willing to become Japanese civilians could migrate and leave the island freely within two years. However, to these Taiwanese fighters, Taiwan was their home. Having no other choices, they would rather go into the war and perish with Taiwan. To fight against the Japanese, they depleted their wealth and even sacrificed their lives.

Regarding the photographic records of the war, no military archive photos were produced by the Taiwanese, and the military records of the Japanese army were made to simply boast its victory over and occupation of Taiwan. Throughout more than a century, the records of the Yi-Wei War from Japan have manifested a propagandist intention, which points to a lack at the same time. Due to differences of knowledge and disappearance of historical memory, it has becomemore difficult to present the historical truth. The photographic records of the Yi-Wei War do not convey truth but merely an interpretation from a certain stance. Historical photos are never about objective facts but the construction of power instead.

Chang May-Ling employs fabricated scenes to represent the Yi-Wei War, utilizing imaginary truth to break through spatial-temporal limit and return to the historical moments from a century ago. She first re-photographs the Japanese military records and turns them into slides. Then, she projects the slides on a wall before constructing war-like scenes with different materials in front of the projected images. These fictional scenes contain mountains and rivers, weaponry and wreckage, as well as destroyed cities and ruins, which symbolize and represent the battlefields from northern to southern Taiwan as well as the fiery smoke and chaotic sights in the war. Meanwhile, the work also serves as a metaphor for the courageous spirit and glory of the anti-Japanese volunteer army from Taiwan, along with their anger, struggle, helplessness, and sorrow. (Mandarin text provided by the artist.)

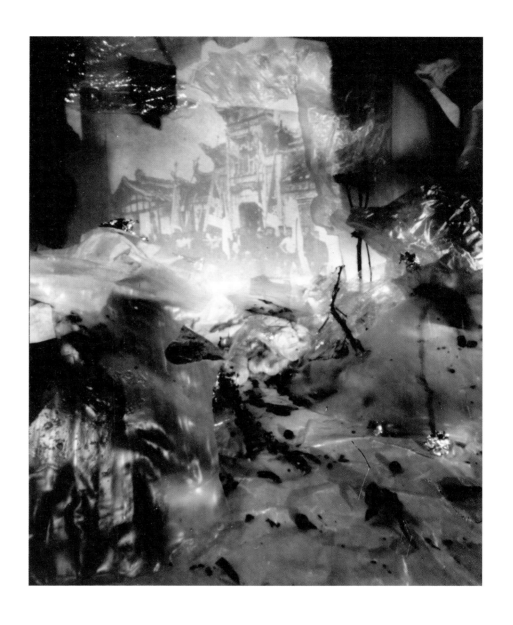

〈五月十一日，基隆城淪陷，日軍逮捕清兵並擄獲其武器及旗幟〉
1995。明膠銀鹽相紙。50.4×40.5公分。國家攝影文化中心典藏。

On May 11, the City of Keelung Fell, and the Japanese Arrested the Qing Soldiers and Captured Their Weapons and Flags
1995. Gelatin silver print. 50.4×40.5 cm. Collection of the National Center of Photography and Images.

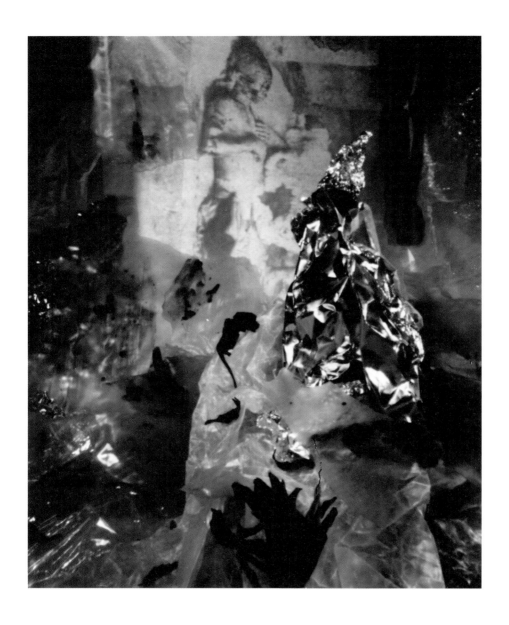

〈六月十八日，苗栗尖筆山之役〉
1995。明膠銀鹽相紙。50.4×40.5公分。國家攝影文化中心典藏。

On June 18, the Battle of Jianbi Mountain in Miaoli
1995. Gelatin silver print. 50.4×40.5 cm. Collection of the National Center of Photography and Images.

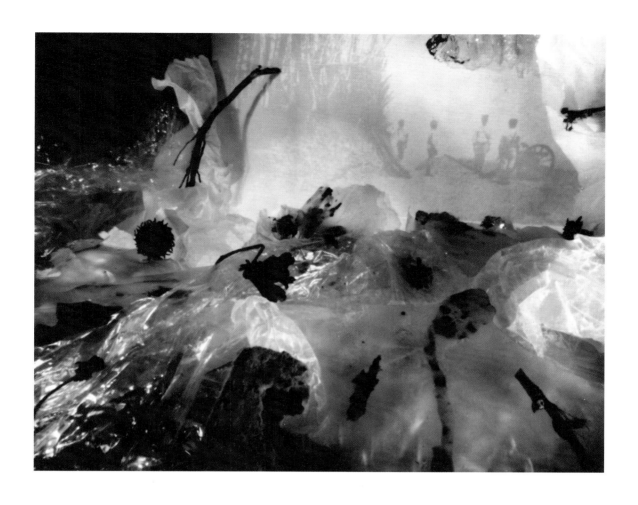

〈七月八日，彰化八卦山之役〉
1995。明膠銀鹽相紙。40.5×50.4公分。國家攝影文化中心典藏。

On July 8, the Battle of Bagua Mountain in Changhua
1995. Gelatin silver print. 40.5×50.4 cm. Collection of the National Center of Photography and Images.

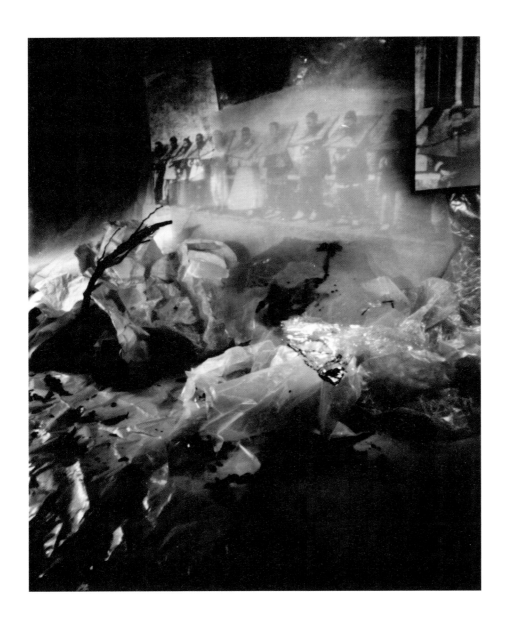

〈八月二十二日，嘉義城淪陷，日軍逮捕戰死守軍之家屬並施以刑具〉
1995。明膠銀鹽相紙。50.4×40.5公分。國家攝影文化中心典藏。

On August 22, Chiayi City Fell, and the Japanese Army Arrested the Family Members of the Dead
Defenders and Tortured Them
1995. Gelatin silver print. 50.4×40.5 cm. Collection of the National Center of Photography and Images.

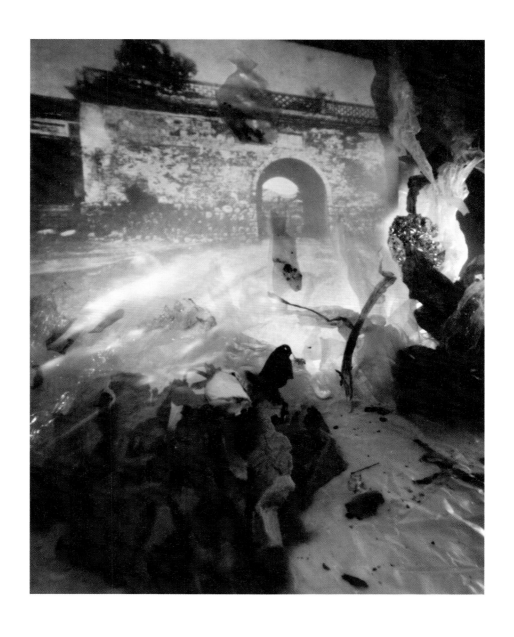

〈八月二十八日，鳳山城淪陷〉
1995。明膠銀鹽相紙。50.4×40.5公分。國家攝影文化中心典藏。

On August 28, Fengshan City Fell
1995. Gelatin silver print. 50.4×40.5 cm. Collection of the National Center of Photography and Images.

梅丁衍
MEI Dean-E

1954年生，1977年文化大學美術系畢業，1985
紐約普拉特學院藝術碩士。梅丁衍早期喜愛
古典藝術，後跟廖修平學習版畫，開始嘗試
不同創作媒材及技巧的實驗技法，並轉向觀
念藝術的呈現。在美求學期間，深受達達主
義及杜象（Marcel Duchamp）的影響，畢業後
開始反思臺灣處境及身分認同問題。1992年梅
丁衍回到臺灣後，跨文化的視野及臺灣社政
的亂象成為他創作的題材，他擅長轉化歷史
物件，並以諷諭的形式一語雙關地挑動觀眾
的敏感神經。

Born in 1954, and graduated from the Department
of Fine Arts, Chinese Culture University in 1977,
and received his MFA from Pratt Institute, New
York in 1985. In the early days, Mei was fond of
and concentrated on classical art. Later, after he
studied printmaking with Liao Shiou-Ping, he began
experimenting with different media and techniques,
gradually shifting to conceptual art. During his time
in the US, he was deeply influenced by Dadaism and
Marcel Duchamp, and after graduation, he started
reflecting on Taiwan's situation and the question of
identity. In 1992, Mei returned to Taiwan, where
his intercultural vision and Taiwan's socio-political
tumults became his creative topics. He specializes
in transforming historical objects, through which he
provokes the audience's sensitive nerves with ironic
double entendre.

《台灣西打》系列
Taiwan Cider Series

〈非常陽公園〉、〈尋找黃土水〉、〈時局青春慰〉
Fei Chang Yang Park, Looking for HUANG Tu-Shui, The Fleeting Flamboyance of Youth

〈非常陽公園〉、〈尋找黃土水〉、〈時局青春慰〉三件作品屬於梅丁衍於2008年開始創作的《台灣西打》系列。梅丁衍透過收藏的日據時期及冷戰時期臺灣居民的生活舊照為素材，使用數位影像技術拼組歷史記憶，以虛擬實境還原殖民地鄉愁，進而詰問臺灣身分認同的本質問題。其創作理念「西打」由英文Cider直譯，在戰後臺灣接受美援的1960年代，成為一種象徵快樂時髦的暢銷飲料。然而，來臺灣的西打卻不是真正的蘋果汁，而是帶有蘋果酸味的果漿飲料，梅丁衍將西打視為一種文化暗喻，以攝影為媒介，探討臺灣在全世界的奇特處境，融合達達及觀念藝術手法，挑戰有關意識型態、權力關係、身份認同等各種迷思。

《台灣西打》系列審視臺灣政治歷史的劃痕，無論是從眾喜愛以假亂真的西打飲料，或著是外來政權的輪替統治，都顯示著臺灣因為歷史斷裂呈現的無重力狀態，缺少了認同的脈絡及對象。他使用這些照片的動機並不單只是在探討照片的「真實」問題，而是企圖挖掘其遺忘真實背後不可見的集體意識問題，諷刺世代之間只餘下短視的流行文化，忘卻影像中的人物曾經存在於歷史上最淒厲悲情的年代。是以影像在拼貼及特效處理後，加重了殖民歷史的異國情調，成為全球化後殖民主義的反諷表徵。（編寫／林學敏，參考自國立臺灣美術館典藏詮釋資料。）

Fei Chang Yang Park, *Looking for HUANG Tu-Shui*, and *The Fleeting Flamboyance of Youth* are from the series of *Taiwan Cider*, which Mei Dean-E started in 2008. With everyday photos of Taiwanese people from the periods of Japanese Colonial Period and the Cold War as his material, he utilizes digital image techniques to piece together historical memories, and restores colonial nostalgia with digitally manipulated reality to further interrogate intrinsic questions related to the identity of Taiwan. Mei uses Cider to express his artistic concept, a popular drink symbolizing happiness and trendiness in the 1960s when Taiwan received the U.S. aid. However, the cider introduced into Taiwan was not the real apple juice but an apple-flavored soft drink with a sweet-sour taste. Utilizing it as a cultural metaphor and photography as his medium, Mei explores Taiwan's unique situation in the world. He blends approaches of Dadaism and conceptual art to challenge a range of myths related to ideology, power relation, and identity.

Through the *Taiwan Cider* series, he examines political and historical trajectories of Taiwan. Whether the pseudo cider drink loved by the public or the rule of the foreign political regime, it indicates Taiwan's rootless state, which is caused by the breaks in its history and leads to a lack of the context and subject of identity. Mei's use of these photographs is not simply to discuss their "authenticity", but to unearth the underlying problem of the collective consciousness that results in the forgotten truth, ironizing the fact that people today only embrace the short-sighted popular culture and fail to remember the truth that people in these photos survived the most sorrowful, tragic era in history. Consequently, with the use of collage and special effects, these images increase the exotic quality of the colonial history, and become an ironic representation of global post-colonialism. (Mandarin text redacted by LIN Hsieh-Min. Refer to the National Taiwan Museum of Fine Arts Collection database.)

自殘圖
Image of Self-abuse

陳界仁在1996年重啟創作之後，以電腦修圖的方式，完成《魂魄暴亂1900-1999》系列作品。這系列的作品，取材自陳界仁所蒐集的各式歷史檔案照片，包含了殺戮、酷刑和國家暴力的影像。〈自殘圖〉縫合左方張作霖於東北清黨及右方1927年Jay Calvin Huston於廣東拍攝的國民黨清黨照片。並將被斬首犯人、背景觀看的民眾以及自相殘殺的連體人替換為自己的形象。如此，彷彿創作者自身也參與了令人不快的歷史事件，不再是置身事外、攝影影像之外無關的觀看者，隱喻著人的多重角色，以及藝術家希望揭開被歷史遮蓋的真實樣貌。（編寫／林學敏，參考自國立臺灣美術館典藏詮釋資料。）

After Chen re-started his creative work in 1996, he employed the technique of photoshop to complete the *Revolt in the Soul & Body 1900-1999* series. To create this series, Chen drew inspiration from a wide range of historical archive photographs which he has collected, including images of killing, excruciating torture, and national violence. The work, titled *Image of Self-abuse*, amalgamates the left image featuring Zhang Zuo-Lin's intra-party purge in Northeastern China, and the right image depicting the purge within the Nationalist Party taken by Jay Calvin Huston in Guangdong in 1927. The artist replaces the images of the decapitated prisoners, the onlooking crowds, and the self-abusing conjoined figure with his own image. By doing so, it is as if the artist himself were involved in these unpleasant historical events rather than being an unrelated outsider to the photographic images, turning this work into a metaphor for the multiple roles of humans as well as for the truth concealed in history. (Mandarin text redacted by LIN Hsieh-Min. Refer to the National Taiwan Museum of Fine Arts Collection database.)

〈自殘圖〉
1996。數位影像輸出。207×259公分。國立臺灣美術館典藏。

Image of Self-abuse
1996. Digital print on laser printing paper. 207×259 cm.
Collection of the National Taiwan Museum of Fine Arts.

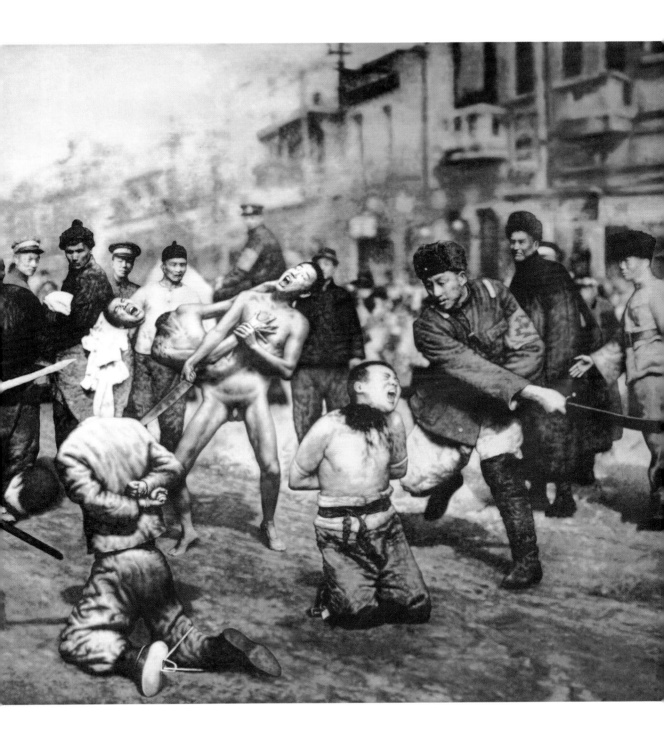

〈四季遊蹤－黑髮的母親〉
2003。黑白照片、影像轉印磁磚、鍍鋅鐵、木料。115.5×92×6公分。國立臺灣美術館典藏。

Journeys in Time – Mother's Black Hair
2003. Black and white photo, tiles with transferred images, galvanized iron, timber. 115.5×92×6 cm.
Collection of the National Taiwan Museum of Fine Arts.

〈四季遊蹤－三地門〉
2003。黑白照片、影像轉印磁磚、鍍鋅鐵、木料。121×186×6公分。國立臺灣美術館典藏。

Journeys in Time – Sandimen
2003. Black and white photo, tiles with transferred images, galvanized iron, timber. 121×186×6 cm.
Collection of the National Taiwan Museum of Fine Arts.

〈四季遊蹤－夜宴〉
2003。黑白照片、影像轉印磁磚、鍍鋅鐵、木料。103×155×6公分。國立臺灣美術館典藏。

Journeys in Time – Evening Banquet
2003. Black and white photo, tiles with transferred images, galvanized iron, timber. 103×155×6 cm.
Collection of the National Taiwan Museum of Fine Arts.

楊登棋（登曼波）
YANG Teng-Chi (Manbo Key)

攝影師與影像創作者，目前定居臺灣臺北。
其創作脈絡與手法往往涉及了拍攝者與被
拍者間的親密關係、對物件與日常生活景
象的觀察。他透過攝影鏡頭，以畫面中的
人物與具隱喻性的空景、對象，直接且暗
喻旁觀者冷眼窺視的視線。2009年以實驗影
像作品《Marrow無憂》獲臺北電影節非劇情
類特別獎，參與過電影《一頁台北》、《艋
舺》美術製作，2011年臺北首次個展《SLEEP
LESSON》，同年也獲邀至新加坡展出。並於
2014年展出上海個展《im/permanence》，2016
年於臺北透明公園舉辦《Document 0-4》影像
個展，2019年以〈父親的錄影帶〉獲當年臺北
美術獎首獎。

A Taiwanese photographer and image artist based in
Taipei. Manbo's creative process involves the intimate
relationship between the photographer and the object,
as well as observations of objects and scenes of daily
life. The figures and spaces captured by Manbo's lenses
are direct metaphors for the cool, distant perspective of
bystanders. Manbo's experimental image work Marrow
(2009) was awarded the Taipei Film Festival Non-
Fiction Special Award, and Manbo has participated in
the art production of films *Au Revoir Taipei* and *Monga*.
Manbo's past exhibitions include his first solo exhibition
SLEEP LESSON in 2011, Taipei, and he was also
invited to exhibit in Singapore; other exhibitions include
solo exhibition *im/permanence* in 2014, Shanghai, and
image solo exhibition *Document 0-4* in 2016, Transpark,
Taipei. Manbos' *Father's Video Tape* artwork was
awarded the grand prize at the 2019 Taipei Art Awards.

父親的錄影帶__複寫：認同
Father's Videotapes_Diverse Identities

中文的「認同」可為動亦可為名詞，作為動詞時，此行為揭示著一種主與被動者間的關係，且常包含有一個「理解」的過程性——從「不理解」轉變至「理解」再到「認同」。無論過程為何、或主與被動方間的關係為何，被動方總是會渴望、期待此行為的發生，甚者轉為「主動」推動此行為的發生。而最後與之出現的「認同感」，便可像是船錨般，消抵了恐懼與懷疑的餘浪。

楊登棋對於「認同」的查考，始於其作品〈父親的錄影帶〉，藉由私人物件與影像的呈現，試圖為自身與自己父親的性向，開啟一個於公共空間裡「被認同」的可能。〈父親的錄影帶__碧兒不談〉則進而向外，紀錄同處於台北當代地下生活裡多元酷兒族群的自我性別認同與彼此間的認同，再映照出主流社會對於其的認同與不認同。

〈父親的錄影帶__複寫：認同〉則是楊登棋向內回到自身家鄉與家族，尋求一個被「家」所認同的想像。在此藝術家回顧了2017年，他穿著阿嬤的洋裝與阿嬤的合照。此照片的靈感起因，是藝術家曾聽到阿嬤說：「已經在幾年前去像館把自己的遺照拍好、收好了。」藝術家賦予自己一個希望被認同的樣貌，並透過自己租棚幫阿嬤紀錄下身後影像、以及將「最真實

一面的自己」涵括進此影像中的行為，去想像阿嬤對於此樣貌的認同。這件作品上一次也是最後一次的展出，是在阿嬤的喪禮。藝術家此回透過行為與產出影像在其家鄉臺中的再現，與家族展開對話，向他們及眾人提出了詰問：2019年，中華民國行政院根據釋憲案及公投結果，提出確保同性婚姻之法律草案，並以中性方式命名為《司法院釋字第七四八號解釋施行法》。「國家認同我們了，那家呢？」而如果婚姻平權已被認可，何以還有許多事，我們仍難以說出口？

複寫，除了是複製以外，也可以是複數、再次的意思。〈父親的錄影帶__複寫：認同〉展間中的物件，便再從〈父親的錄影帶〉一路延伸，從個人身份，擴大至直系及隔代親屬，擴大至國族，再微縮回個人，從中探視認同的多樣性與多面向性，並強調認同並非既定的行為或事實，而是需要反覆構建的。而在這些構建之後，我們又是否真的得取了我們需要的那份「認同感」？（文字／楊登棋、謝賀銘）

To "be identified with" usually requires a process of "understanding," which starts from "a lack of understanding," to "forming an understanding," to finally "achieving identification."

Yang Teng-Chi's (Manbo Key) exploration of "identity" begins with his project, *Father's Video Tapes*. Through the presentation of personal objects and images, he opens up the possibility for his and his father's sexual orientation to "be identified with" in public space. *Father's Video Tapes_avoid a void* extends and expands this objective to document gender identity of the underground community of LGBTQ+ in contemporary Taipei, and further reflects whether the mainstream society identifies with said community or not.

In *Covering Identity*, Manbo turns the other way around and returns to his own family to represent an imagination of how his "family" identifies with him. Back in 2014, Manbo took a picture of himself wearing his a dress with the owner of the dress — his grandmother. The inspiration of the photo was something his grandmother had told him — "I already have my funeral portrait taken at a photo studio and put it away properly." The artist therefore created a look for himself, which he hoped that his grandmother could identify with. Through taking the photo with his grandmother, he imagined how she would identify with such a look. The last time this work was shown in public was at his grandmother's funeral. By displaying this work in his hometown to create a dialogue with his family, Manbo posed a question to both his family and all of us: In 2019, the Executive Yuan of the Republic of China proposed the same-sex marriage bill based on the Constitution and the result of a referendum, and gave the bill a neutral name — "Act for Implementation of J.Y. Interpretation No. 748," which was later passed into law. "So, now that the nation has recognized us, how about the family?" If the right to same-sex marriage has been recognized, why are there still so many things that we find difficult to say to each other?

In addition to referring to replication, *Covering Identity* beckons at plurality and repetition as well. The objects showcased in *Father's Videotapes_Diverse Identities* extend the subject of personal identity, expanding it to immediate, skipped-generation relatives, nation, and again back to personal life. It explores the diversity of identity, which is in fact not a pre-existing action or fact, but something that requires construction again and again. After repeated construction, however, do we really gain the sense of "identity" that we need? (Mandarin text provided by YANG Teng-Chi and HSIEH Ho-Ming)

能也小，人不的功課或隨我心跟的，雖然有些
再加強。你年紀也不小了，不要凡事都要別人叮
依賴性太強對你並沒有好處，對了！你寄來那組
收到了，希望你載告地。元旦將近你心快放寒
暖的假期，但千萬不要忘記作寒假作業，就歸就
後習。最後代為問候祖母及全家平安
祝你 功課進步。好好要連連。
1996.12.28
父字 鑫

展覽現場照：國立臺灣美術館提供。攝影：ANPIS FOTO 王世邦。
On-site view photos courtesy of the National Taiwan Museum of Fine Arts,
shot by ANPIS FOTO (WANG Shih-Pang).

楊順發
YANG Shun-Fa

出生於臺南，現居高雄，從事攝影創作逾三十年。擅長編導式攝影，代表作有《再造王國》（1997）、《野獸橫行》（1999）、《家園游移狀態》（2006）等。作品亦曾受邀至國內外重要藝術機構展出。近年因其「海島計畫」而對臺灣海岸線進行廣泛的田野踏察，其中《台灣水沒》系列曾獲2018年高雄獎。

Born in Tainan, now lives in Kaohsiung. His photography career has spanned over three decades. Known for his work of staged photography, his representative works include *Rebuilding the Kingdom* (1997), *Rampant Beasts* (1999), *Home and Rootless* (2006), etc. His works have been featured in major art institutions both in Taiwan and abroad. In recent years, he has conducted extensive field research to explore Taiwan's coastlines for "The Island Project," in which one of the series, titled *The Submerged Beauty of Formosa*, won the First Prize in the 2018 Kaohsiung Award.

《家園游移狀態》系列
Home and Rootless Series

《家園游移狀態》述說的是高雄紅毛港遷村後，當地居民遺留下來的家園殘跡。歷經40年的禁建，於2007年匆匆遷離居住幾個世代的土地，此事件不論是在生活上或是精神上，都對紅毛港人造成巨大且深遠的衝擊。本系列透過遷村後再訪紅毛港，如考古般地搜羅世代生活的證據，如家俱、相框、老桌椅等物件，佈置成如記憶或夢境般的場景；有時甚而以人物再現對家鄉之回望，是面對廢墟的心理演繹，更是創傷後的魂牽夢繫。此外，藝術家利用暗房技術，使底片過曝、發霉，呈現歷史和記憶隨時間消逝的悲涼之感——這些被遺忘的地方，是他們生命中的廢墟，廢墟卻因為生命的痕跡而繼續存在，並輾轉返生成另一種記憶，一種無法確定是否存在過的記憶。紅毛港遷村後便失了「根」，村民不論到何處都成了「外來客」、「新移民」，就如一艘艘找不到碼頭靠岸的船隻，漂流於人、土地、歷史與生命之間。（藝術家提供）

Home and Rootless portrays the ruinous homes left behind by residents of Hong Mao Gang Village in Kaohsiung after the relocation of the village. In 2007, after four decades of building prohibition, the residents were hurriedly relocated from the place where they had inhabited for generations. This event has had an enormous and lasting impact on the residents of Hong Mao Gang Village, whether in terms of their life or spirit. In this series, the artist revisits Hong Mao Gang Village after the relocation. Like an archaeologist, he gathers proofs of living from generations of the inhabitants, such as furniture, photo frames, old tables and chairs, to stage memory-like or dream-like scenes. He also employs figures to represent the inhabitants' backward glance of home, which serves as an interpretation of their psyche when facing the ruins and their unending remembrances after the trauma. Furthermore, the artist utilizes various darkroom techniques, such as rendering the films overexposed and moldy, to delineate the feeling of desolation occurred when history and memory disappear — these forgotten places might be ruins in these people's lives, but the ruins continue to exist through the traces of life, and subsequently return as a different form of memory, which one cannot be certain as to whether or not it has really existed. After the relocation, the residents of Hong Mao Gang Village have lost their "root"; and wherever they go, they are "outsiders" and "new immigrants." Like boats without a harbor, they have been drifting among people, places, history and life. (Mandarin text provided by the artist.)

〈家園游移狀態No. 03〉
2005。數位輸出。94.8×184.8×4.5公分（含框）。國家攝影文化中心典藏。

Home and Rootless No. 03
2005. Digital print. 94.8×184.8×4.5 cm (framed). Collection of the National Center of Photography and Images.

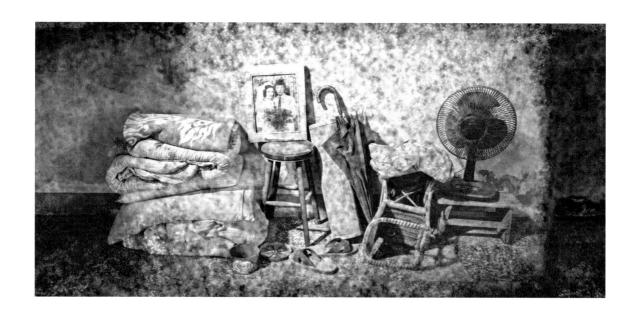

〈家園游移狀態**No. 08**〉

2006。數位輸出。94.8×184.8×4.5公分（含框）。國家攝影文化中心典藏。

Home and Rootless No. 08

2006. Digital print. 94.8×184.8×4.5 cm (framed). Collection of the National Center of Photography and Images.

〈家園游移狀態**No. 13**〉

2007。數位輸出。94.8×184.8×4.5公分（含框）。國家攝影文化中心典藏。

Home and Rootless No. 13

2007. Digital print. 94.8×184.8×4.5 cm (framed). Collection of the National Center of Photography and Images.

III.

再檔案
Re-archiving

杜韻飛
TOU Yun-Fei

1975年出生於臺北，目前生活與創作於臺北。1998年畢業於羅德島設計學院攝影學系，1999至2009年間從事報導攝影，2007年、2008年兩屆金鼎獎最佳攝影獎得主。自2010年起獨立創作，2012年《生殤相》獲選為第十屆桃源創作獎首獎，但此後不曾再申請任何的獎項、補助與展覽。杜韻飛作品偶見受邀於國內外畫廊、攝影節與美術館展出。

Born in 1975, Taipei, where he now lives and works. He graduated from the Department of Photography, Rhode Island School of Design in 1998. From 1999 to 2009, he worked as a photojournalist, and was awarded Best Photographer of the Golden Tripod Awards in 2007 and 2008. Since 2010, he has started making independent art projects. His work, *Momento Mori*, was awarded the First Prize of the 10th Taoyuan Contemporary Art Award in 2012; afterwards, he has stopped making submissions and applications for any awards, grants, and exhibitions. From time to time, Tou's work can be seen in art galleries, photo festivals and art museums in Taiwan and abroad.

未來祖宗像
Ancestral Portraits: the Future

《未來祖宗像》仿擬德國藝術家湯瑪斯・魯夫的肖像作品，拍攝對象為1987年後出生、進入青春期後，父親為臺灣人、母親為東南亞或中國籍的子女。在影像中，他們面無表情，身著全球化下的日常服飾。

杜韻飛為此計畫與「獨立評論@天下」合作，開設網路專欄，邀請各界人士就此一攝影計畫進行書寫，並曾在唯一一次個展中，於獨立樓層展示這些文章。作者認為，閱讀作品不應受限作者有限的經驗，作品所引發的討論也是作品的本身。（藝術家提供）

Ancestral Portraits: the Future imitates German artist Thomas Ruff's photography portraits, and features adolescent teenagers born after 1987, who have Taiwanese fathers and mothers from either Southeast Asia or China. In these images, these teenagers, while wearing daily clothing commonly found in today's globalized context, wear no expression whatsoever on their faces.

For this project, Tou collaborates with "Independent Opinion@CommonWealth Magazine," and launched an online column, inviting his audience from all walks of life to write about this photography project. In his solo exhibition featuring this project, which was the only one ever held so far, he dedicated an entire floor to exhibit these articles. To the artist, the reading of an artwork should not be confined by an artist's limited experience, whereas the discourses produced by the artwork are also part of the work as well. (Mandarin text provided by the artist.)

專欄搜尋關鍵字：杜韻飛、未來祖宗像、獨立評論

Independent Opinion Column
(Mandarin only)

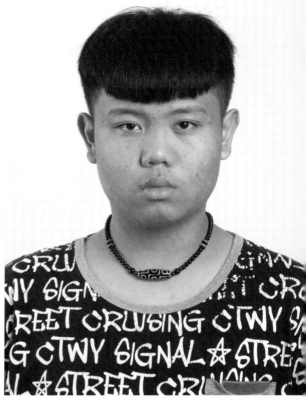

〈鄭雅勻，嘉義市，2018〉
2018。相紙輸出。90×64公分。藝術家提供。

ZHENG Ya-Yun, Chiayi City, 2018
2018. Print. 90×64 cm. Courtesy of the artist.

〈張修瑋，台東市，2018〉
2018。相紙輸出。90×64公分。藝術家提供。

ZHANG Xiu-Wei, Taitung City, 2018
2018. Print. 90×64 cm. Courtesy of the artist.

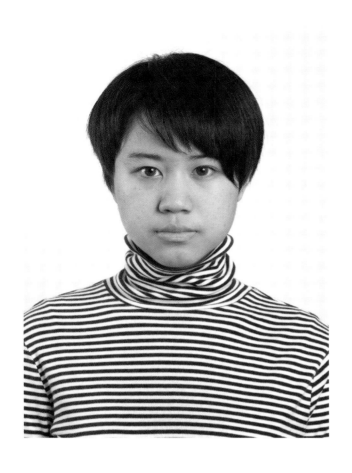

〈曾令瑋，高雄市，2018〉
2018。相紙輸出。90×64公分。藝術家提供。

ZENG Ling-Wei, Kaohsiung City, 2018
2018. Print. 90×64 cm. Courtesy of the artist.

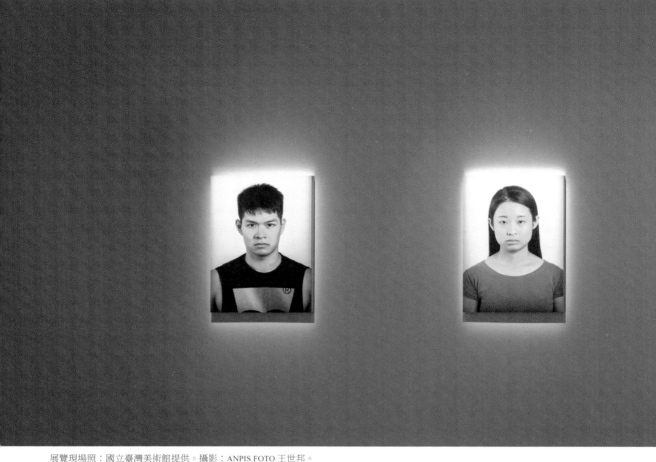

展覽現場照：國立臺灣美術館提供。攝影：ANPIS FOTO 王世邦。
On-site view photo courtesy of the National Taiwan Museum of Fine Arts,
shot by ANPIS FOTO (WANG Shih-Pang).

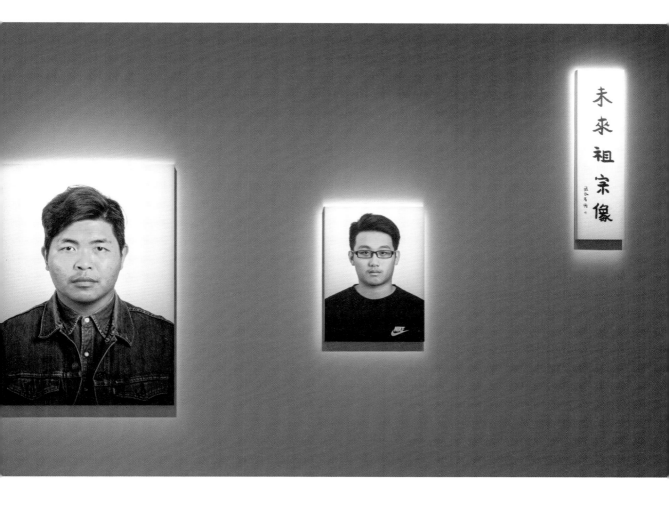

出版品
An Untitled Publication

此未命名之出版品為攝影計畫《未來祖宗像》的變奏，郵寄至收藏者手上的瓦楞紙箱貼有先賢先烈郵票，蓋有臺北故宮郵局郵戳，以及戴口罩的女性coser照片⋯⋯等等，這些充滿話語的細節，共同構成作品的一部分。

出版品內容物為四盒各一千片的拼圖，拼圖背面印有學者黃宗潔為此計畫所書寫的文字，完成後所有拼圖共同組成一張巨幅肖像和一篇文章。肖像的主角同為外箱照片中的女子，不同之處為，完成後拼圖中的女子並無穿戴口罩，女子的臉龐清晰可見。

此一探究認同議題的攝影計畫，透過自行選擇以「扮裝」造型現身拍照的新住民二代女子，創造了認同鬆動與流動的可能性。（藝術家提供）

For *Ancestral Portraits: the Future*, an untitled publication is made as an extension as well as a variation of the project. The collector of the publication receives a cardboard box. Pasted on the box is a stamp of respected historical figures, with the postmark of the National Palace Museum in Taipei, and the image of a female coser with her face covered by a face mask. These expressive details constitute a part of the work.

The content of the publication, on the other hand, comprises four boxes of jigsaw puzzles, each containing one thousand pieces. The article written by scholar Huang Tsung-Chieh for this project is printed on the back of these puzzles. When these puzzles are completed, they form a large portrait and the entire article. The subject of the portrait is the girl from the image on the cardboard box. The only difference is that the girl is not wearing a face mask in the portrait image formed by the puzzles, and her face is fully revealed.

This photography project explores the issue of identity; and through the image of the girl, who independently chooses to have her portrait taken "in costume," it destabilizes identity and creates a possibility for identity to become fluid. (Mandarin text provided by the artist.)

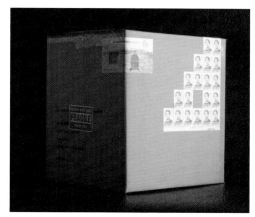

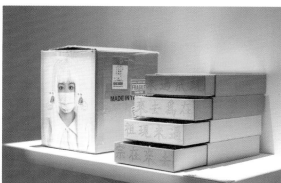

展覽現場照：國立臺灣美術館提供。攝影：ANPIS FOTO 王世邦。
On-site view photos courtesy of the National Taiwan Museum of Fine Arts, shot by ANPIS FOTO (WANG Shih-Pang).

〈出版品〉
2020。瓦楞紙箱、硬紙盒、影像印刷於拼圖。拼圖：150×100公分。藝術家提供。

An Untitled Publication
2020. Corrugated box, rigid paperboard box, image printed on jigsaw puzzle. Puzzle: 150×100 cm. Courtesy of the artist.

周慶輝
CHOU Ching-Hui

1965年生於臺灣，畢業於世界新聞專科學校（現為世新大學）。1988年，正值臺灣解嚴後新聞媒體蓬勃發展的年代，他基於對攝影的強烈興趣，進入新聞攝影行業，同時也自行投入攝影創作，拍攝專題攝影計畫，深入描寫當代社會的特定生活群體，並以「創作攝影」的言說方式，開了幾個窮年耗月的專題攝影計畫，包括：《停格的歲月—癩瘋村紀事》（現統稱為《行過幽谷》系列）、《消失的群像—勞動者紀事》、《野想—黃羊川計畫》等。周慶輝曾多次受邀參與國際各大美術館、藝術中心、畫廊展出個人創作，近期展覽包含《台北雙年展》（2014）、《中國長江國際影像雙年展》（2015）、《北京國際攝影雙年展》（2015）、《加拿大蒙特婁地下藝術節》（Art Souterrain, 2017）、《四川安仁雙年展》（2019）展出。2022年應臺灣駐西班牙辦事處邀請，將於葡萄牙里斯本著名的「東方博物館（Museo do Oriente）」舉辦《人的莊園》大型個展。

Born in 1965, Taiwan. Graduated from Shih Hsin School of Journalism (now Shih Hsin University). In 1988, as the development of news media flourished in Taiwan during the post-martial law period, Chou launched his photojournalist career fueled by his passion for photography. At the same time, he also dived into the creation of photography and started various photography projects to profoundly portray specific communities in contemporary society. Expressing his ideas through "creative photography," he initiated several long-lasting photography projects, including *Frozen in Time – Chronicle of a Leper Colony* (now commonly called the *Out of the Shadows* series), *Vanishing Breed – Workers Chronicle*, *Wild Aspirations – The Yellow Sheep River Project*, etc. Chou has exhibited his works internationally at many art museums, art centers, and galleries. His recent exhibitions include the *Taipei Biennial* (2014), the *Chang Jiang International Photography and Video Biennale* (2015), the *Beijing Photo Biennial* (2015), *Art Souterrain* 2017 in Montreal, Canada (2017), the *Anren Biennale* in Sichuan (2019), and more. In 2022, he was invited by the Taipei Economic and Cultural Office in Spain to present a large-scale solo exhibition, *Animal Farm*, at the well-known Museo do Oriente in Lisbon, Portugal.

《行過幽谷》系列
Out of the Shadows Series

藝術家周慶輝在經過一年的「新聞勞作」生活後，開始自覺尋找能使其發自內心的獨處及獨白的空間。他於拍攝樂生療養院12年後重新回顧《行過幽谷》系列，殘存的影像彷彿預言了樂生療養院注定消失的命運，只餘下黑白畫面敘述著病房內反覆且毫無盡頭的生死與無奈。後來的觀眾只能在檔案照片註記中，那些黯淡的人名以及空間圖像裡，感受著那些攝影當下留存的現實，和已消逝事物曾經存在的痕跡。周慶輝認為「外界的事物騷擾著相機的暗箱」，而他內心的暗箱則打擾著外界的事物，他並且為他為何攝影感到疑惑，他自敘：「我總是違逆現實環境又太多的妥協，自以為聰明用各種方法來換取攝影的自由度卻讓自己陷入泥沼。設定攝影計畫是因為讓自己的靈魂有一飄流的方向，我反覆告訴自己透過攝影能使心情平靜，但往往內在撕裂，掙扎衝突不斷，好像自我衝突是完成計劃的必要條件，當孤獨面對衝突時是將自己推進分裂的邊緣，我迷醉死亡、痛苦、消失的幻影，我想我會持續拍攝下去是因為我擔心我不會再拍了。」（編寫／林學敏，參考自藝術家提供之作品介紹。）

After a year of "journalistic labor", Chou Ching-Hui started becoming aware that he needed a space for himself and self-expression. Twelve years after photographing the Lo-Sheng Sanatorium, he revisits the *Out of the Shadows* series. The remnant images seem to have predicted the sanitorium's fate of unavoidable disappearance, leaving only the black-and-white images to recount the endless cycle of life, death and feeling of helplessness in the wards. The audience today can only perceive the realty and time preserved in the photographs and the traces of faded existences through the discolored names, the images of the space, and the notes of archive photos. To Chou, "the external things disturb the dark box of the camera," and the dark box within his mind, on the other hand, seems to disturb the external world as well. The reason why he takes photos has baffled him. According to Chou, "I always disobey reality yet make too many compromises, being a clever clog trying to gain freedom in photography through different means and only to get myself stuck eventually. I make photography projects because I need to set a direction for my drifting soul. I tell myself repeatedly that photography calms my mind, but I feel constantly torn inside as well as the incessant struggles and conflicts, as if self-contradiction has become a prerequisite to the completion of a project. When facing these conflicts alone, I push myself towards the edge of breaking apart. I am fascinated with the illusion of death, pain, and disappearance. I think that I continue doing photography because I am afraid that I will not do it again." (Mandarin text redacted by LIN Hsieh-Min. Refer to the statement provided by the artist.)

〈行過幽谷：天使〉
1993。明膠銀鹽相紙。55.5×37.3公分。國家攝影文化中心典藏。

Out of the Shadows: Angel
1993. Gelatin silver print. 55.5×37.3 cm. Collection of the National Center of Photography and Images.

〈行過幽谷：榮患一號葉學文是個靦腆的老人，曾養了不少的流浪狗、貓〉

1992。明膠銀鹽相紙。37.3×55.5公分。國家攝影文化中心典藏。

Out of the Shadows: Bashful YEH Hsueh-Wen, Veteran Patient No. 1, Cared for Stray Cats and Dogs
1992. Gelatin silver print. 37.3×55.5 cm. Collection of the National Center of Photography and Images.

〈行過幽谷：這雙手是典型痲瘋病人的鳥爪，十指戴滿了各式黃金戒指，形成一個突兀的景象。
這雙手的主人叫魏茂祿〉
1992。明膠銀鹽相紙。37.3×55.5公分。國家攝影文化中心典藏。

***Out of the Shadows: Claw-like Hands Are Typical of Lepers. The Owner of these Hands, WEI Mao-Lu,
Wears an Implausible Assortment of Gold Rings on All Fingers***
1992. Gelatin silver print. 37.3×55.5 cm. Collection of the National Center of Photography and Images.

Lost Society Document

WEI Tzu-Chi, WU Yun-Jui, TAN Piek-Lu, CHANG Chen-Shen, LIN Yi-Han , CHUEH He-Han, KUO I-Chen, LU Lu-Sheng, CHANG Kuei-Hua, WANG Yu-Tzu, LU Yi-Juan, LAN Ching-Hung, TENG Yu-Hua, CHEN Chia-Hsin, YANG Yu-Hsuan, CHANG Li-Wei, LU Wen-Ling, TSOU Yu-Kai, SONG Yu, HAO Yi-Wei, CHANG Chen-Tung, LIU Meng-Hua, YANG Yi-Lin, FENG Pin-Tzu, WENG Tzu-Mei, LIU An-Chieh, CHEN Yun-Ju, CHEN Hsin-Tung, JAU Ming, CHEN Hsi-Sheng, LIU Yen-Fu, TAI Chen-Tung, CHEN Liang-Yu, CHEN Tsun-Yu, CHANG Yi-Jen, HSIAO Ya-Hsuan, LI Chih-Yun, CHUNG Hsin-Fang, PAN Yan-Nan, SU Yun-Yi, TSAI Yun-Ju, CHEN Yu-Sheng, HSU Ming-Chien, SU Sheng-Ya, HUANG Chia-Lin, TAN Hsing, LEE Yi-Heng, CHENG Yun, CHIU Lien-Jan, TSENG Jo-Ying, CHIANG Kuan-Yi, LIN Pei-Yao, LAI Yu-Tso, KANG Ian, LIN Chih-Yu, HSIEH Ming-Chien, HU Han-Chieh, HUNG Chen-Fang, HUANG Chih-Ching, HUANG Pei-Wei, WU Zhen-Wei, CHEN Pei-Han, YANG Pei-Hua, YU Tsung-Hsien, CHEN Yi-Ju, CHIEN Li-Yun, WU Ying-Shan, YEH Tzu-Jen, HUO Jung, CHIEN Yu-Jen, LIN Jung-Hsuan, SHEN Meng-Ju, HSIAO Yi-An, WAN Dan-Ya, HSIAO Min-Ling, TSAO Heng-Cheng, LIN Yi-Cheng, KUNG Pang-Ying, LEE Pin-Ru, TSAI Chao-Hsun, LIU Yu-Shan, CHUNG Yu-Ming, CHUANG Ya-Ting, WU Yung-Yu, HOU Si-Chi, KUO Yu-Chiao, SU Yi-Wen, HSIEH Chia-Yu, CHENG Yung-Hui, TSENG Yi-Chieh, WANG Yu-Hui, LIN Ching-Yuan, KUO Yu-Chi, WANG Ching-Chun, LI Ting-Ju, WU Chung-Chun, LIU Hsin, CHEN Yu-Ning, CHANG Shu-Ching, CHUNG Yueh-Ting, TU Hsiang-Yi, LI Hsin-Ping, HUNG Wei-Ting, LIN Yi-Tzu, LIN Yu-Hsuan, SHIH Ju-Hsuan, CHOU Fang, LIN Chih-Yu, CHEN Ju-Ying, Tang Min, CHEN Ying-Jung, CHUANG Kai-Chu, LIU Sang-Chi, LU Mei-Hui, WU You-Yu, LIN She-Shen, HSU Wei-Ting, LIN Yen-Hsiang, WANG Pao-Chieh, HSIEH Yi-Ting, LIN Yu-Ju, CHIANG Ya-Hsuan, LU Tsun-Chen, WEI Chen-Che, WANG Ying-Wen, LIN Yen-Yu, HUANG Yu-Wen, CHANG Tseng-Yi, WU Hsin-Yu, LO An-Hsuan, LEE Hao-Shih, SHIH Wei-Yen, HO Wan-Ning, CHANG Yu, SHAO Chia-Chi, CHU Chia-Hui, TAI Hsin-Yu, CHANG Ya-Jou, CHANG Yuan-Chi, JUAN Yi-Hsing, LIN Yu-Wei, PENG Yi-Hang, CHEN Je-Jung, TSAI Tung-Yi, CHIU Yi-Ching, LEE Yi-Jen, HUNG Ming-Chuan, TING Jung-Hsuan, LIN Yi, YANG Hsuan, TANG Wen-Ching, SHEN Ying-Jung, TSAI Shih-Hsiang, HSIAO Jo-Yu, CHIANG Yu-Cheng, LIEN Hsin-Yu, WU Hsiang-Chun, HUANG Yi-Chieh, LIN Pei-Yun, LAI Yi-Hsiang, CHIANG Jo-Je, CHEN Chia-Hung, YU Hsin-Ju, YANG Wei-Yuan, TSAI Shang-Chen, HUANG Ting-Hui, LIN Chien, LIAO Kai, CHEN Yi-Ching, CHANG Ching-Lan, SU Li-An, PENG Fan-Hsiou, Chen Po-Hsien, HU Chia-Hsin, CHEN Jie-Yu, SUN Yi-An, HSIEH Tsai-Lin, LIU An-Ti, CHUANG Ta-Wei, LIU Chia-Yi, WU Yi-Ching, SU I-Han, CHEN Ke-Jou, CHEN Jie, CHEN Hsin-En, CHEN Wei-Wen, CHENG Kai-Teng, HSIA Chi-Jen, HSIEH Cheng-Lin, YU Chia-Hsuan, FAN Yu-Wen, TAI Yi-Fei, CHENG Chia-Ning, HSU Geng-Wei, WEN Yu-Jung, WANG Yu-Jung, CHOU Te-Jung, CHANG Yun, HSIN Yeh, HUANG I-Chen, YU Chen-Yu, CHEN I-Wei, CHEN An, TSENG Hsing-Pei, CHEN Chia-Chi, HUANG Hsing, TAN Kian-Ming, CHANG You-Chung, HSU Yu-Ling, KUO Po-Yu, LU Chao-Yi, HSIEH Chi-Yuan, TAN Yung-Hong, Wen Yau, KO Huai-En, LIN Chun-Wei, LIAO Yung-Chen, HUANG Shih-Yi, LIN Jou-Yu, YANG Ya-Ting, CHEN Yu-Ting, LEE Ching-Yu, CHEN Chiao-Yun, WANG Chien-Hua, WU Nei-Hui, LEE I-Ju, HUANG Po-Han, TANG Ching-Wen, WANG Pei-Shan, CHEN Yi-Chin, TSENG Yao-Yi, PAI Yen-Tzu, HSIAO Wen-Ying, OGASAWARA Yoshito, WANG Yu-Ting, LIU Yen-Tung, KUO Yu-Chun, KUO Fu-Chiḥ, CHEN Yi-Shan, LIU Yi-Ling, HUANG Yi, LIN Yi-Chun, LIAO Chao-Hao, KUO Li-Wen, HSU Szu-Ying, GENG Jie-Sheng, LIN Hsiu-Jen, LIU Chi-Tsen, HUANG Ting-Yun, JAU Jian-Hung, LIU Yi-Ling, WANG Hsuan-Wei, LEE Hsiao-Tsui, WU Yi-Hsuan, SUN Shih-Ting, WU Hsin-Jue, WU Cheng-You, LEE Hen-Ju, TZENG Yi-Shin, CHEN Kai-Shiang, HSU Hsin-Yun, YANG Wen-Ya, LIN Heng-Ru, CHEN Tzu-Ya, CHANG Chu-Ting, HSU Chieh-Min, TU Chih-Wei, HSU Jia-Wei, HUANG Shun-Ting, TSAI Wei-Yi, WU Bo-Hung, FANG Yi-Mai, CHEN Yi-Chung, WU Yu-Ting, CHAN Yueh-Lin, CHANG Shauba, WENG Huang-Hao, LIU Yue-De, LIU Guan-Ling, HUANG Tzu-Jui, HUANG Li-Yin, LIN Shiou-Jen, LU Wan-Shu, CHIEN Yi-An, WEN Chih-Yin, CHEN Pin-Han, LI Pei-Fen, FAN Jia-En, LIN Yan-Chu, JUO Fang-Chi, HUANG Guan-Jiun, CHANG Yu-Rung, LIN Chin-Shin, PENG Yi-Hsuan, LAI Yong-Lin, LIN Chia-Jen, TSENG Shin-Yi, HSU Ying-Yu, TSENG Lin-Yuan, LIU Yi-Ling, HUANG Mei-Fu, CHEN Yi-An, GAN Ming-Jiun, CHEN Yun-Chi, YANG Bo-Jiun, KUO Fang-Chun, WU Ping-Sheng, CHIEN Yi-Hung, CHIU Ling-Lin, TSAI Pei-Chi, LIN Hsiao-Han, TENG Hsin-Jung, HUANG Ko-Wei, LI Yi-Fan, MI Chih-Chi, MA Jiun-Ru, LIN Cheng-Chung, WENG Yi-Han, TSAI Pei-Ting, WENG Ning, HSIEH Chen-Feng, LEE Shin-Yi, WANG Yueh-Hsin, CHEN Hsing-Han, HU Zi-Chi, LEE Si-Ying, KO Chun-Yao, KUO Pin-Chun, WEI Ze, LIN Hsin-Mei, YEH Yu-Chang, HUANG His-Chen, HUANG Shih-En, CHANG Chih-Han, LIN Wen-Tsan, YANG Jia-An, CHUANG Yao-Jia, JUO Tz-Luo, LAI Hsiao-Ying, CHUANG Ya-Jiun, HO Meng-Hsuan, TUNG Meng-Jen, LIU Jie, HUANG Ling, HSIEH Ren-Bin, LIAO Wan-Ting, LIN Rui-Yang, WANG Yu-Han, LIU Tzh-Fan, CHEN Guo-Hua, CHOU Chyuan-Li, LU Jen-Yi, LU Yi-Hsuan, TSAI Chia-Ying, CHANG Feng-Yu, MA Chen-Yu, LIN Ting-Ru, WU Nian-Cheng, PEI Chih-Hau, LIU Yi-Ting, CHANG Juo-Yu

海市蜃樓：台灣閒置公共設施抽樣踏查攝影計畫
Mirage: Disused Public Property in Taiwan

2010年2月底新學期開始，姚瑞中在擔任臺北藝術大學美術系與師範大學美術系的第一堂課，詢問學生對這堂課的期待：是希望按照一般上課方式由老師講授相關知識，或者願意用這堂課進行「蚊子館」踏查？兩所大學美術系五十幾位同學決議以全臺蚊子館調查做為學期作業。在半年返鄉調查裡，彙整出147處「蚊子館」案例，編輯出版厚達684頁的《海市蜃樓－台灣閒置公共設施抽樣踏查》，勾勒出臺灣社會荒謬現狀，體現出「錯誤政策比貪污還可怕」之事實。經由媒體大幅報導引起政府高層關注，甚至副總統來電關切以及行政院長召見，並指示各單位進行調查，要在一年內活化蚊子館，若不能活化的則考慮拆除。2011年10月8日，在政府宣佈一年內的活化週年，再次動員70名同學、收錄了111處「蚊子館」案例的第二本踏查報告與攝影展出爐，2013年10月出版第三集，2014年10月出版第四集，至2019年底總共出版了七集，揭露了超過800處案例。從一個學期作業為開端，與學生們共同參與的藝術行動就像一顆投入池塘的小石子，激起不斷向外延伸的漣漪，擾動了一個表面寧靜的假面社會，讓人不得不直視現實。它既是姚瑞中與其學生的集體藝術行動，也是以藝術方式掀起社會現實問題的一角，開展全民對此議題的問題意識。（藝術家提供）

When the new semester began in February 2010, Yao Jui-Chung, presiding over the first classes of the fine arts departments at Taipei National University of the Arts and the National Taiwan Normal University, asked the students about their expectations for this class: did they wish to follow the normal class format, where the teacher would teach related knowledge, or would they like to use the class to do a "mosquito hall" investigation? The fifty-some students at the two universities decided to make a Taiwan-wide "mosquito hall" survey as the assignment for this semester. Through half a year of investigation across the island, the students identified one hundred and forty seven "mosquito hall" locations, compiling the 684 page book *Mirage: Disused Public Property in Taiwan*, which outlines an absurd situation in Taiwanese society, embodying the fact that "misguided policy is worse than corruption." It was widely reported in the media, and attracted a high level of attention from the government, even prompting a call from the Vice President and a visit from the Premier of the Executive Yuan, who advised all relevant departments to engage in an inspection of said facilities, ordering them to revive all mosquito halls within a year or consider demolishing them. Through two years of homework, the students' art action was like a stone trown into a pond, sending ripples outwards, shaking a presumably calm society and forcing them to face reality. The significance and value of this "participation" lie in the fact that it is both a collective action by Yao Jui-Chung and his students, and in that it used artistic methods to hold up a social issue to scrutiny and engage the awareness of the people in regards to that issue. (Provided by the artist.)

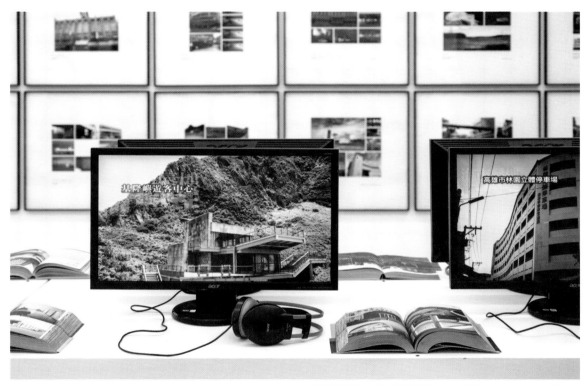

展覽現場照：國立臺灣美術館提供。攝影：ANPIS FOTO 王世邦。
On-site view photo courtesy of the National Taiwan Museum of Fine Arts,
shot by ANPIS FOTO (WANG Shih-Pang).

〈海市蜃樓：台灣閒置公共設施抽樣踏查攝影計畫〉
2010-2019。黑白攝影輸出、黑色鋁框、文件、書、影像紀錄。單件作品70.8×70.8×3.4公分，尺寸依現場而定。
國立臺灣美術館典藏。

Mirage: Disused Public Property in Taiwan
2010-2019. Black and white photos with black aluminum frams, documentary, books, videos. 70.8×70.8×3.4 cm each,
dimensions variable. Collection of the National Taiwan Museum of Fine Arts.

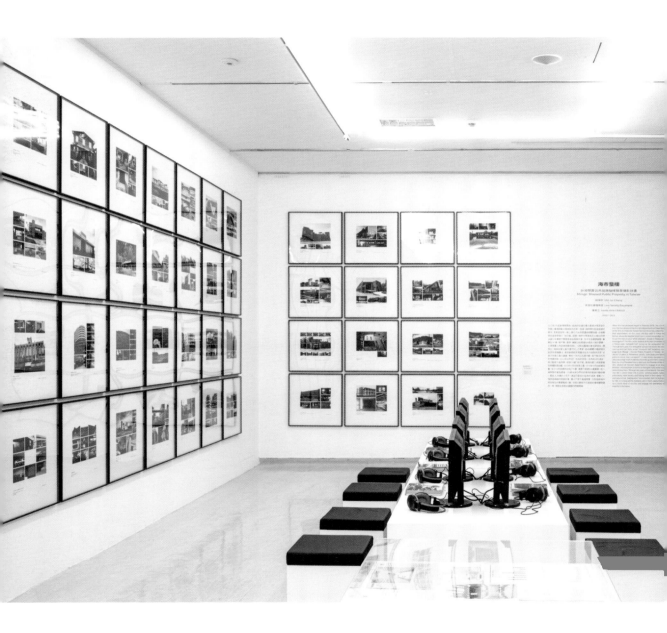

展覽現場照：國立臺灣美術館提供。攝影：ANPIS FOTO 王世邦。
On-site view photos courtesy of the National Taiwan Museum of Fine Arts,
shot by ANPIS FOTO (WANG Shih-Pang).

陳敬寶
CHEN Chin-Pao

畢業於紐約視覺藝術學院攝影系，現為國立臺北藝術大學美術學系博士候選人。他以《片刻濃妝：檳榔西施》系列紀實肖像的作品受到注目；《迴返計劃》與《記憶晶體》系列作品藉由並置被攝者的文件書寫與擺拍式攝影，追索現實、真實與記憶的微妙界域；《天上人間》藉由拍攝與民宅比鄰的小廟與墳墓，以「住屋」為隱喻，探討幽微的生死學，同時將臺灣描繪為神、人與亡靈共居的土地。近年來進行的《尋常人家》，則著重於描繪記錄當代臺灣人居家生活的樣態。陳敬寶於2008年獲頒日本北海道東川賞海外攝影家獎，並於2018年參與法國亞爾攝影節展出；目前居住並工作於臺灣新北市。

Chen Chin-Pao holds a BFA in Photography from the School of Visual Arts, New York, and is now a PhD candidate at the Department of Fine Arts, Taipei National University of the Arts. He first made his fame with a documentary portrait series, titled *A Moment of Beauty — Betel Nut Girls*. His *Circumgyration* and *Memory Crystal* series combine writing of documents about his photographed subjects and posed photography to explore the subtle boundary among reality, authenticity and memory. *Heaven on Earth* features small temples and graves in the vicinity of people's homes, using "housing" as a metaphor for discussing the subject of life and death, while portraying Taiwan as a place co-inhabited by deities, humans and ghosts. *Ordinary Household*, an ongoing project which Chen has been working on in recent years, concentrates on documenting the ordinary life in contemporary Taiwanese households. In 2008, Chen was awarded the Overseas Photographer Award of the Higashikawa Awards, Hokkaido, Japan. He was also featured in Les Rencontres d'Arles in 2018. Chen now lives and works in New Taipei City, Taiwan.

《檳榔西施》系列
Betel Nut Beauties Series

「檳榔西施」同時具有公開、定時、定點三項特質，是以引發對社會良善風氣的憂慮；但在20世紀末的臺灣仍蔚為風尚，並挑戰執法的公權力、社會輿論與道德的尺度。攝影者認為此行業深具本土色彩，是臺灣俗民文化代表之一；希圖藉由微觀的田野影像調查，呈顯出特定時空座標中，特定臺灣族群其生活、文化及美學觀，為世紀末的臺灣社會留存見證。

「檳榔西施」以女體作為慾望的消費對象，是庶民階級自我意識的展現；由於經濟的富裕，此族群一方面頗為欣賞自己的政治觀，一方面藉檳榔攤裡閃爍的各色燈管和透明櫃的花俏設計，展現其美學觀。

檳榔西施們屬於臺灣新生世代的一群。出生於戰後政經迅疾轉變的時代，享受豐裕的物質生活是追求的目標；大體偏好暫時性的工作：他們可能工作一段短時間，從檳榔攤消失，稍後出現在另一家店。他們是新價值觀的部分呈顯：青少年受到金錢、物慾的魅惑，失去了對自身其他可能性的思考。

就攝影者而言，拍攝歷程是將檳榔西施由被慾望的「物」還原成「人」的過程。本系列影像更接近肖像而不是定義裡的報導攝影。因而，這個專題的本質是：攝影者試圖展現檳榔西施（植基於經濟因素）的「自我展現」。（藝術家提供）

"Betel nut beauties" exhibit three qualities: they are seen in the public at fixed locations during regular hours. Consequently, their presence is considered a hazard to good social atmosphere and custom. However, in late 20th century, betel nut beauties were still quite popular in Taiwan, which became a challenge to the authority of public power, public opinion, as well as moral standard. To Chen Chin-Pao, this particular industry is characteristic of Taiwan and represents an aspect of the Taiwanese local culture. Therefore, through his microcosmic field survey of photography, he attempts to demonstrate the life, culture and aesthetics of this particular Taiwanese community at specific places and time to document the Taiwanese society at the turn of the century.

With the female body as the subject of desire, betel nut beauties demonstrate the self-awareness of the class of common people. Due to affluence in life, they are often proud of their own political views, and utilize betel net stalls as a stage to display their aesthetics by installing colorful, twinkling lights and mesmerizing designs on transparent cabinets.

Part of a younger generation in Taiwan, betel nut beauties were born in the post-war era characterized by drastic political and economic changes, and pursue a life of material abundance and enjoyment. They mostly prefer temporary jobs — they might work for a short time, and disappear from a betel nut stall, only to start working at another one later. Their lifestyle becomes a partial manifestation of a new value: These teenage girls could be tempted by money and material desires, consequently losing the chance to think about their potential and other possibilities.

For the photographer, the journey of photographing this series represents a process of restoring the betel nut beauties from "objects" of desire back to "humans." Instead of being viewed as photojournalism, this series is more like portrait photography. In essence, Chen aims to emphasize on the "self-presentation" (based on financial consideration) of the betel nut beauties. (Mandarin text provided by the artist.)

〈檳榔西施系列-1〉
1996。彩色照片、聚酯塗佈RC、沖印、富士高亮膠捲軟片。50×50公分。國立臺灣美術館典藏。

Betel Nut Beauties-1
1996. Fujifilm high-bright C-print photo paper. 50×50 cm. Collection of the National Taiwan Museum of Fine Arts.

〈檳榔西施系列-6〉
1996。彩色照片、聚酯塗佈RC、沖印、富士高亮膠捲軟片。50×50公分。國立臺灣美術館典藏。

Betel Nut Beauties-6
1996. Fujifilm high-bright C-print photo paper. 50×50 cm. Collection of the National Taiwan Museum of Fine Arts.

《韓戰反共戰俘的政治紋身》系列
Anti-communist Tattoo on Prisoners-of-war from the Korean War Series

1950至1953年韓戰期間，以美國為首的聯合國軍隊共擄獲華籍戰俘約21,300人，部分中國人民志願軍戰俘決定返回大陸，部分戰俘選擇來臺灣。這些離鄉背井，沒有拒絕權利的年輕人，被稱為「反共義士」，從此成為中華民國政府對中國大陸來歸人士的代名詞。抵臺後的「反共義士」，有多達9,234人經過編裝訓練後加入國軍行列，從此各自過著不同際遇的人生。

當年在韓國戰俘營期間，擁共與反共戰俘曾爆發激烈鬥爭，國民政府派員滲入發起「刺青運動」，所以來臺戰俘身上幾乎都留下大小不一的反共圖騰或文字刺青。每人紋身動機與過程可能不盡相同，有人是基於堅決反共的立場，也可能因為非自由意志或抗拒情況下，至使其因遍身反共標語刺青而不敢回中國，只得選擇來臺。不論如何，他們都同樣因皮膚上的政治紋身，從此與親人離散數十年，生命中的精華階段成了親情斷裂的時期。

1987年，故總統蔣經國宣布開放探親後，反共戰俘為達成重返故土與親人團聚心願，只好用盡手段把身上的政治紋身再去除，有人用雷射去青，有人用手術割掉有刺青的皮膚部位再縫合，有人用化學藥劑把皮膚整得凹凸不平，很諷刺地，為了與離散數十年親人重聚，他們身上再度留下新的印記。

這群參與韓戰的老兵，在大歷史洪流中，連選擇簡單而卑微做自己的權利都被剝奪，只能用皮膚來承受歷史的苦難，成為展示意識形態與權力的看板。（藝術家提供）

During the Korean War from 1950 to 1953, the United Nations forces led by the U.S.A captured a total of 21,300 Chinese war prisoners. Among these war prisoners, some from the Chinese People's Volunteer Army decided to return to mainland China after their release; and some decided to move to Taiwan. These young men, who left their homeland and had no right to refuse, were called "anti-communist heroes", a name given to the mainlanders that decided to come to Taiwan by the government of the Republic of China. After arriving in Taiwan, 9,234 of these "anti-communist heroes" were included and trained to join the national army, and had led different lives ever since.

In the Korean War prisoner camp back then, pro-communist and anti-communist war prisoners had intense conflicts. The Nationalist government sent out agents to infiltrate the camp and launched a "tattoo movement". Those who came to Taiwan later all had anti-communist totems or text tattoos of various sizes on their bodies. The motivations for getting the tattoos varied, however: some got the tattoos due to a resolute anti-communist stance, whereas others received the tattoos against their free will, and consequently had no choice but to come to Taiwan because they dared not go back to China with anti-communist slogan tattoos. No matter their reasons, they were all separated from their families for decades due to the political tattoos on their skin. The prime of their lives thus became almost a lifetime of separation from their loved ones.

In 1987, the former president Chiang Ching-Kuo announced that family visits to China were allowed. In order to return to the homeland and reunite with their families, these anti-communist war prisoners tried various means to get rid of their political tattoos. Some used laser; some surgically removed the tattoos and stitched up the wounds; and others applied chemicals on the tattooed skin, making it uneven and creased. Ironically, they all had to leave new marks on their bodies so that they could reunite with their loved ones that they had not seen for decades.

Throughout the flow of the grand history, these veterans who fought in the Korean War were deprived of the simplest and most basic right to be themselves. They could only bear the historical suffering with their skin, which was used for displaying ideology and power.
(Mandarin text provided by the artist.)

〈韓戰反共戰俘的政治紋身：廖禮華〉
2013。數位輸出。47.6×68公分。國家攝影文化中心典藏。

Anti-communist Tattoo on Prisoners-of-war from the Korean War: LIAO Li-Hua
2013. Digital print. 47.6×68 cm. Collection of the National Center of Photography and Images.

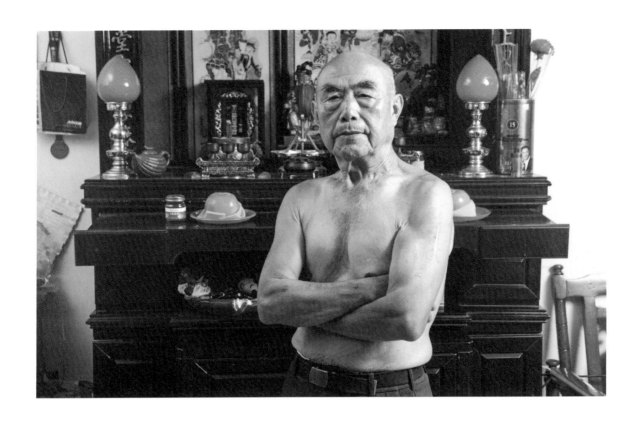

〈韓戰反共戰俘的政治紋身：陶良琪〉
2013。數位輸出。47.6×68公分。國家攝影文化中心典藏。

Anti-communist Tattoo on Prisoners-of-war from the Korean War: TAO Liang-Chi
2013. Digital print. 47.6×68 cm. Collection of the National Center of Photography and Images.

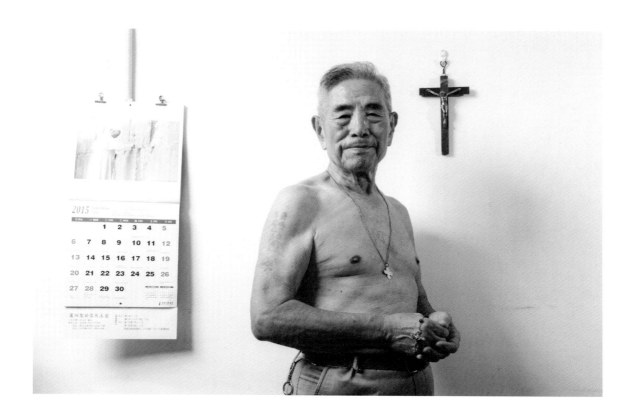

〈韓戰反共戰俘的政治紋身：李鴻範〉
2013。數位輸出。47.6×68公分。國家攝影文化中心典藏。

Anti-communist Tattoo on Prisoners-of-war from the Korean War: LI Hung-Fan
2013. Digital print. 47.6×68 cm. Collection of the National Center of Photography and Images.

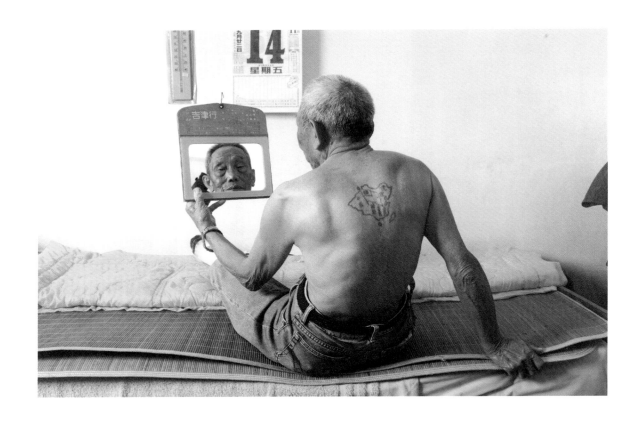

〈韓戰反共戰俘的政治紋身：周資望〉

2013。數位輸出。47.6×68公分。國家攝影文化中心典藏。

Anti-communist Tattoo on Prisoners-of-war from the Korean War: CHOU Tzu-Wang
2013. Digital print. 47.6×68 cm. Collection of the National Center of Photography and Images.

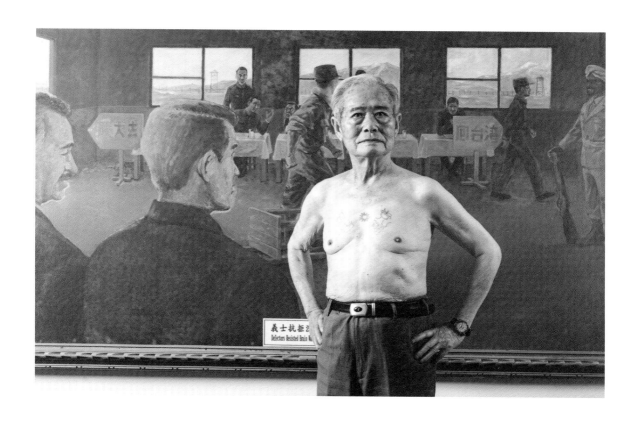

〈韓戰反共戰俘的政治紋身：潘海波〉
2013。數位輸出。47.6×68公分。國家攝影文化中心典藏。

Anti-communist Tattoo on Prisoners-of-war from the Korean War: PAN Hai-Po
2013. Digital print. 47.6×68 cm. Collection of the National Center of Photography and Images.

IV.

檔案的歷史編纂學
Historiography of Archiving

李立中
LEE Li-Chung

李立中，六年九班臺南人，文化大學印刷系畢業，曾在臺北從事雜誌編輯，2012年辭掉工作搬回臺南。近年來迷戀賽鴿歸巢本能，欲透過賽鴿文化研究，對歸屬、宿命、後全球化等議題建構自我對話路徑。計劃透過幾件敘事作品《台灣粉鳥三部曲》來書寫一部臺灣賽鴿史，同時也是臺灣近代史。2019年首部曲《竹篙山戰役與紅腳笭》獲台新獎提名與高雄獎優選，2020年《台灣空戰記事》參與《台灣美術雙年展》，2021年新作《Pontanus的日誌本》，則將自己化身為主角史詩般穿越時空尋找心愛鴿子的身影。

Born in 1980, Tainan. After he graduated from the Department of Printing (now Department of Information and Communication), Chinese Culture University, he worked as a magazine editor in Taipei. In 2012, he left his previous job and moved back to Tainan. In recent years, having been fascinated with the homecoming instinct of racing pigeons, he hopes to construct a pathway of self-dialogue through researching on the culture of pigeon racing to explore issues related to the sense of belonging, destiny, and post-globalization. With the narrative works in his *Taiwan Pigeon Trilogy*, Lee plans to write a Taiwanese history of pigeon racing, which is also a history of early modern Taiwan. In 2019, the first chapter of the trilogy, titled *Battle of Mt. Zhugao and Red Feet Ling*, was nominated for the Taishin Arts Award and won the Honorable Mention in the Kaohsiung Award. In 2020, his *The Memo of Formosa Air Battle* was featured in the *Taiwan Biennial*; and in his latest project of 2021, *Pontanus' Journal*, Lee transforms himself into the protagonist who traverses epically through time to search for his beloved pigeon.

台灣空戰記事
The Memo of Formosa Air Battle

李立中無意間從網路上看到一篇報導，內容關於二戰時的軍鴿事蹟與一張照片，闡述著鴿子在人類視角下是如何突破重圍安然回家，完成交付的使命。也因這則報導讓他開始好奇臺灣賽鴿／軍鴿的過往與今生，為釐清報導的真實性，李立中開始著手調查爬梳相關史料與文件後，才發現1944年的臺灣空戰不只臺灣少年工的參與，甚至國際聞名的臺灣賽鴿也流傳著一支神秘的鴿系血脈，以及在殖民流動的空間轉換下，面臨殘生空間的消逝與資本開發衝擊的飛雁新村竟也都牽涉其中。於是，他嘗試讓他的鴿子再重新演繹1944年10月12日上午的空戰情景，以鴿子的視角看見這片天空的喧囂與平靜，重返現場之際也想像那股歸巢的衝勁，體驗如何肩負身為一隻軍鴿的使命，卻又甩不掉命運的主宰與操弄。（藝術家提供）

Lee Li-Chung accidentally found an online article about military homing pigeons during WWII with a photograph. The article describes, from a human point of view, how the military pigeons survived difficulties and returned home safely, accomplishing the missions they were entrusted. Because of this article, Lee became curious and subsequently encaptivated by the past and present of racing/military pigeons in Taiwan. In order to authenticate what was stated in the article, Lee started investigating and teasing out historical materials and documents. To his surprise, he found out that the Formosa Air Battle of 1944 was not just participated by young Taiwanese factory workers, but also involved a mysterious pigeon lineage from Taiwan's internationally reputed racing pigeons, as well as the Feiyan New Village facing dilapidating space and disappearance under the impact of capitalistic development throughout the changing colonial scenes. Therefore, Lee lets his pigeon take center stage to re-interpret the air battle in the morning of October 12, 1944. This work unveils the chaos and tranquility of the sky from the pigeon's perspective, and revisits its homecoming impulse through imagining the experience of a tasked military pigeon that could not escape the dominance and manipulation of fate. (Mandarin text provided by the artist.)

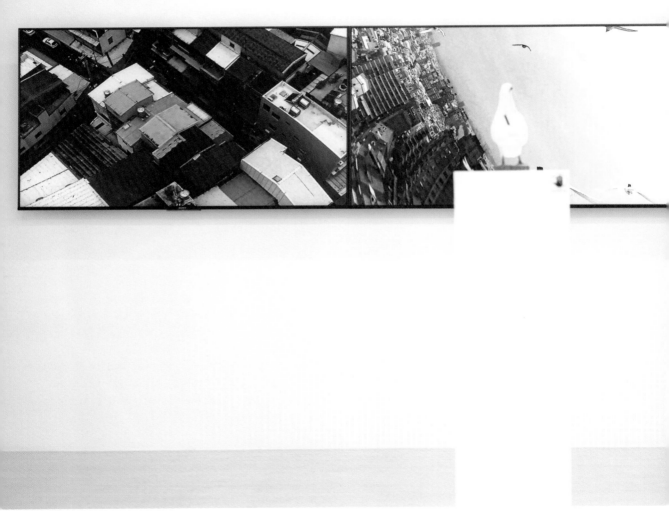

〈台灣空戰記事〉
2020。平面攝影、三頻道錄像、複合媒材、檔案文件與剪報。尺寸依場地而定。藝術家提供。

The Memo of Formosa Air Battle
2020. Photographs, 3-channel videos, mixed media, documentary and newspapers. Dimensions variable. Courtesy of the artist.

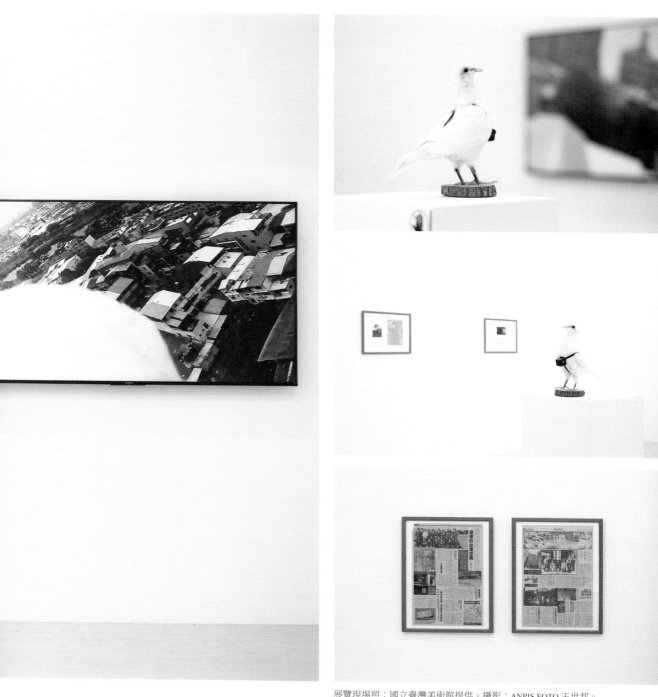

展覽現場照：國立臺灣美術館提供。攝影：ANPIS FOTO 王世邦。
On-site view photos courtesy of the National Taiwan Museum of Fine Arts,
shot by ANPIS FOTO (WANG Shih-Pang).

台灣演示引戰記事

視覺構成：何明桂
Picture arranged by HO Ming-Kuei.

展覽現場照：國立臺灣美術館提供。攝影：ANPIS FOTO 王世邦。
On-site view photo courtesy of the National Taiwan Museum of Fine Arts,
shot by ANPIS FOTO (WANG Shih-Pang).

鄭亭亭
CHENG Ting-Ting

生於1985年，臺灣。畢業於倫敦西敏大學攝影學及金匠大學純藝術碩士。其曾在臺灣、香港、日本、英國、西班牙、匈牙利等地舉行個展。他的作品曾經在巴西聖保羅《Videobrasil當代藝術雙年展》、《TIVA臺灣國際錄像藝術展》、《東京雙年展》、倫敦Iniva國際視覺藝術中心、越南Zero Station、首爾MMCA國立美術館等地出現。在作品中，他利用影像、聲音、物件、行動以及參與，來討論文化及國家認同，以及不同社會團體之間的關係。

Born in 1985, Taiwan. Graduated from MA Photographic Studies at University of Westminster and MFA Fine Art at Goldsmiths College. Cheng had solo shows in Taiwan, Japan, Spain, UK and more. Her works were seen in *Bi-City Biennale of Urbanism/ Architechture* (China), *Contemporary Art Festival Sesc_Videobrasil* (São Paulo), *Tokyo Biennale, Iniva* (London), *MMCA* (Seoul), National Art Museum of China (Beijing)...etc. In her practice, she examines our cultural, national and racial identities through reinterpreting archival materials to construct narratives in the current context.

明日出土
Unearth Tomorrow

《明日出土》以一張來自17世紀，由不知名的
歐洲畫家所畫的素描開始，為了尋找該畫家的
視角，藝術家鄭亭亭到了聖薩爾瓦多城的現址
和平島，試圖前往圖中的島嶼，觀眾於展場空
間內移動，緩緩地靠近或遠離影像中的島嶼，
卻無法登島。此外，藝術家也到了和平島的
西班牙諸聖教堂遺跡，撿拾並記錄這些歷史碎
片。碎片們被無限放大，在考古現址照片所製
成的大圖輸出前，漂浮在空中。隨著殖民者的
來去，島嶼的名字也不斷的變更，所有的現在
和過去都會在明日出土。（藝術家提供）

Unearth Tomorrow centers on the Spanish Colony in
the north of Taiwan in the 17th century. It started with
an old drawing made by an unknown European painter,
describing an island seen from Tuman, which used to
be called San Salvador during the Spanish colonization.
In order to find the perspective and the location of the
unknown painter at the time, Cheng took a series of the
photographs while approaching the said island from
Tuman. The series of photographs are designed to be
arranged from small to big from the entrance of the
exhibition space, as if the audience is approaching the
island when it arrives, and moving away from the island
when it leaves. The second part of the project includes
images of unknown objects floating in the dark, which
were collected by Cheng at the archeology site of San
Salvador on Tuman. Everything will be unearthed
tomorrow. (Provided by the artist.)

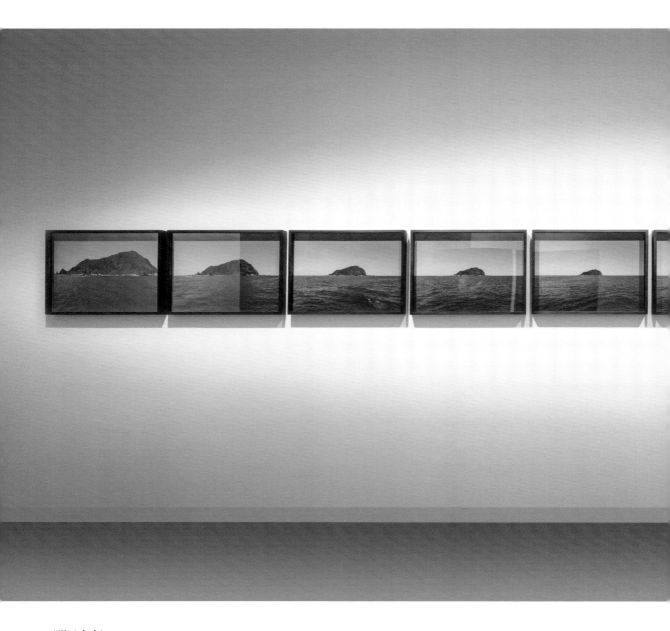

〈明日出土〉
2021。裱框噴墨輸出與大圖輸出。14×21公分×1件，45×60公分×9 件，90×90公分×5件，裝置尺寸依場地而定。藝術家提供。

Unearth Tomorrow
2021. Framed inkjet print, digital print. 14×21cm×1 piece, 45×60 cm×9 pieces, 90×90 cm×5 pieces, installation dimensions variable. Courtesy of the artist.

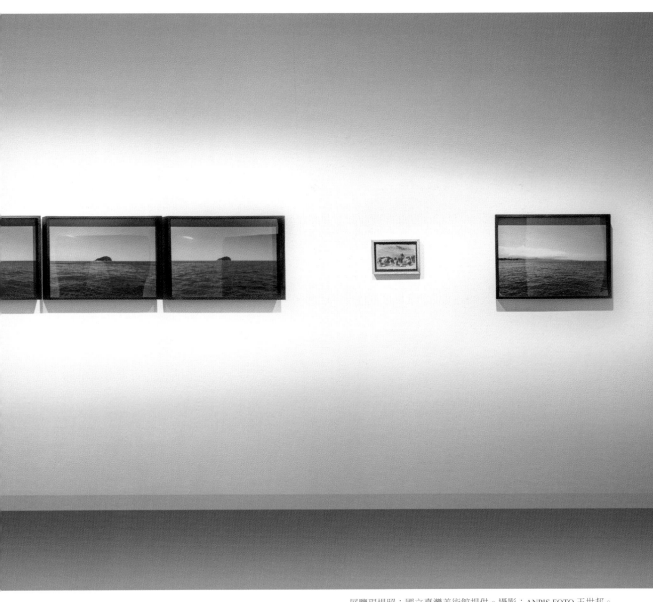

展覽現場照：國立臺灣美術館提供。攝影：ANPIS FOTO 王世邦。
On-site view photo courtesy of the National Taiwan Museum of Fine Arts,
shot by ANPIS FOTO (WANG Shih-Pang).

展覽現場照：國立臺灣美術館提供。攝影：ANPIS FOTO 王世邦。
On-site view photo courtesy of the National Taiwan Museum of Fine Arts,
shot by ANPIS FOTO (WANG Shih-Pang).

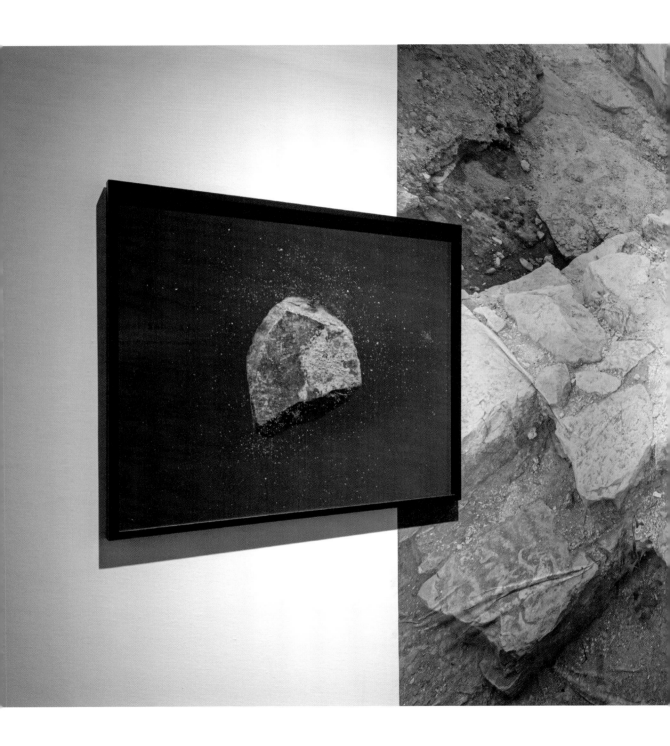

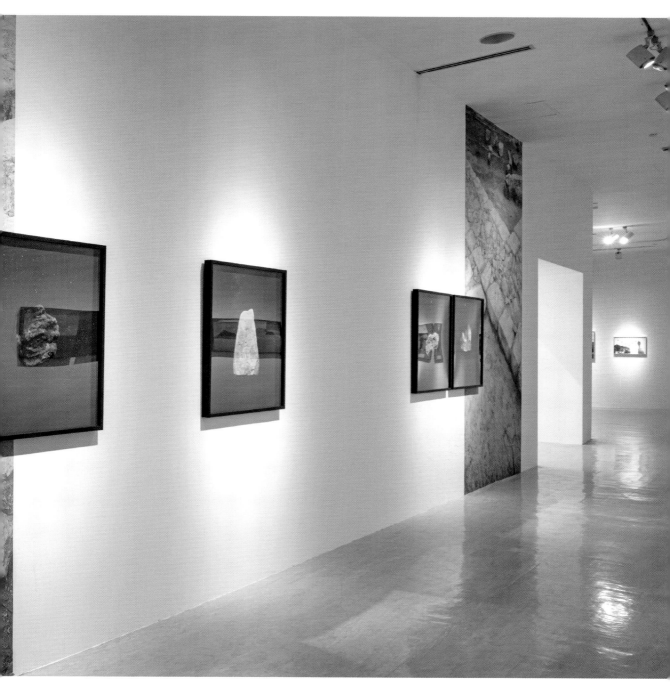

展覽現場照：國立臺灣美術館提供。攝影：ANPIS FOTO 王世邦。
On-site view photo courtesy of the National Taiwan Museum of Fine Arts,
shot by ANPIS FOTO (WANG Shih-Pang).

藍仲軒
LAN Chung-Hsuan

1991年生於臺北，畢業於紐約普瑞特藝術學院純藝術研究所，現生活與創作於臺北。其作品以抹除、修改、與再造的方式處理攝影、現成影像、文獻與歷史物件。近期展覽包括2022年德國威瑪公共藝術計畫「Future Nostalgia FM」與2021年德國萊比錫也趣藝廊個展《餘溫》，也曾於紐約、東京、金浦、北京、臺北等地展出。藍仲軒曾赴日本與芬蘭駐村，獲集保當代藝術賞、文化部新人推薦特區、新樂園藝術空間新秀獎等獎項，作品獲臺灣集中保管結算所、藝術銀行、新光三越文教基金會等機構典藏。

Born in 1991, Taipei. Lan Chung-Hsuan holds an MFA in Fine Arts from Pratt Institute, New York, and currently lives and works in Taipei. His practice deals with photography, existing images, documents, and historical objects by means of erasure, alteration, and remaking. His recent exhibitions include the public art project "Future Nostalgia FM," in Weimar, Germany in 2022, and his solo exhibition *Residual Heat* at Aki Gallery Leipzig Prospect, Leipzig, Germany in 2021. He has exhibited in New York, Tokyo, Gimpo, Beijing, and Taipei. Lan has conducted art residencies in Japan and Finland. Lan is the recipient of the Taiwan Depository and Clearing Corporation (TDCC) Contemporary Arts Award, and has been selected into the Ministry of Culture's Made in Taiwan-Young Artist Discovery and the Shin Leh Yuan Art Space's Emerge program. His works are included in the collections of the TDCC, the Art Bank, and the Shin Kong Mitsukoshi Cultural & Educational Foundation.

戰地是一廂情願，而郵票是一張紙
A Battlefield Is a Wishful Thinking, yet a Stamp Is a Piece of Paper

攝影拼貼系列《戰地是一廂情願，而郵票是一張紙》將展出九件作品。這些作品集合了藝術家前往金門探訪軍事遺址與紀念場館時所拍攝的照片，包括金門迎賓館、退役戰車、歌手鄧麗君勞軍畫面、以及其他戰地遺址。之後，藝術家將具有國家性的早期郵票實物拼貼於照片之上，以不同的符號、字詞、或無意義的圖形來回應或遮擋這些「觀光」照片中的戰爭景物。

金門的戰地早已成為了一種不切實際的憧憬，它不斷的被循環利用在不同的層面上，作為一種操作政治與情感的浪漫工具；印有政治宣傳的郵票也類似如此，它們仍然意圖傳遞著某種幾近被淘汰卻又不被消滅的信息。當兩者結合時，它們既相互建立著脈絡，卻也相互扼殺彼此的脈絡——光榮而沈重的戰地成為了幻影，偉大的思想只不過一張薄小的紙片，最後變得什麼也不是。（藝術家提供）

Nine works from the photographic collage series, *A Battlefield Is a Wishful Thinking, yet a Stamp Is a Piece of Paper*, are on view in the exhibition, which are based on photographs taken by the artist during his visit to Kinmen. These photographs feature military and memorial relics and sites, such as the Kinmen Guesthouse, retired tanks, images of singer Teresa Teng's visit to Kinmen for paying tribute and entertaining soldiers, along with other military ruins. The artist pastes old stamps, which represent a nation, onto the photographs, forming various signs, words, or meaningless patterns as a way to respond to or conceal scenes and objects of wars and battles in these "tourist" photographs.

Kinmen as a battlefield has long become an impractical yearning, which is repeatedly recycled and utilized on different levels as a nostalgic instrument for political and emotional manipulation. Stamps printed with political propaganda constitute a similar instrument, which is still used to convey messages that are almost obsolete but not quite. When the two are combined in this work, they are complementary to the formation of each other's contexts while canceling them out at the same time — the once glorious and burdened battlefield becomes a mirage, and the great ideology is eventually reduced down to a tiny, practically insignificant, piece of paper. (Mandarin text provided by the artist.)

〈**女神**〉
2020。無酸噴墨相紙、郵票。48×86公分。藝術家提供。

Goddess
2020. Archival inkjet print, stamps. 48×86 cm. Courtesy of the artist.

〈莊敬自強〉
2022。無酸噴墨相紙、郵票。42×30公分。藝術家提供。

Be Careful and Be Strong
2022. Archival inkjet print, stamps. 42×30 cm. Courtesy of the artist.

〈我願意〉
2022。無酸噴墨相紙、郵票。70×100公分。藝術家提供。

Yes I Do
2022. Archival inkjet print, stamps. 70×100 cm. Courtesy of the artist.

圍牆
The Wall

從一位無名臺灣人於1965年在德國所拍的旅行照片出發，〈圍牆〉搭建了一堵柏林圍牆式的展牆，並將其拍攝的照片放大輸出貼於牆面。在這些照片裡，我們會發現飄揚在德國街頭的中華民國國旗、在德國一處公園的中華民國展位、德國戰後的都市重建、改建前的舊柏林圍牆、還有該國的科技發展與文化留存等景象。深入研究後，我們會發現這位臺灣人造訪德國的原因是為了參訪當年的慕尼黑車展，而中華民國也有參展，國旗被並列在了展會官方的宣傳文宣之上。

當這些照片以早期海報的形式張貼於圍牆上後，覆蓋於上面的則是街頭的塗鴉覆蓋。塗鴉，是一種次文化的佔地盤的最直接方式。牆上塗鴉內容偏向臺灣意識，意指了該內容作為一種次文化的宣示，試圖反抗另一個時空的主流意識。然而這面圍牆還未如柏林圍牆坍倒，仍然矗立著的它依舊代表了一種拒絕性。又或者說，我們嚮往遠方的景象，卻又意圖避開那裡曾發生過的歷史悲劇，忽略了該地之所以為該地就是因為曾經有過的悲劇。透過另一個國家的分裂歷史，〈圍牆〉隱喻著臺灣對自身歷史、現況、與未來的多重歧異想像。（藝術家提供）

Starting from photographs taken by an anonymous Taiwanese traveler in Germany in 1965, *The Wall* comprises a faux wall in the style of the Berlin Wall which shows enlarged prints of the photographs taken by the unknown traveler. In these images, one can see the national flag of the Republic of China waving in the German streets, an R.O.C. stall in a park in Germany, the country's post-war urban reconstruction, the old Berlin Wall before its conversion, as well as Germany's technological development and cultural preservation. After further research, one discovers that the Taiwanese traveler visited Germany to see the International Mobility Show in Munich that year, which was joined by the R.O.C. and its national flag was printed in the official marketing materials.

The artist pastes the old poster-like prints of these photographs on the faux wall, and then covers them with street graffiti, which is considered the most direct subcultural form of occupation. The content of the graffiti, on the other hand, displays the Taiwanese consciousness, indicating the graffiti is a subcultural declaration to fight against the mainstream consciousness from a different era. However, unlike its now collapsed counterpart, the Berlin Wall, the wall that still stands erect in the exhibition denotes a form of denial. In other words, as one longs for the sight in a distant place, he or she also averts intentionally the historical sorrows which had befallen the place, losing sight of the fact that the place is known precisely because of its tragic past. Through the lens of another country's history of division, *The Wall* is a metaphor for Taiwan's history, as well as the multiple and divergent imaginations of its present and future. (Mandarin text provided by the artist.)

展覽現場照：國立臺灣美術館提供。攝影：ANPIS FOTO 王世邦。
On-site view photos courtesy of the National Taiwan Museum of Fine Arts, shot by ANPIS FOTO (WANG Shih-Pang).

〈圍牆〉
2022。照片塗鴉裝置。尺寸依現場而定。藝術家提供。

The Wall
2022. Photographs and graffiti installation. Dimensions variable. Courtesy of the artist.

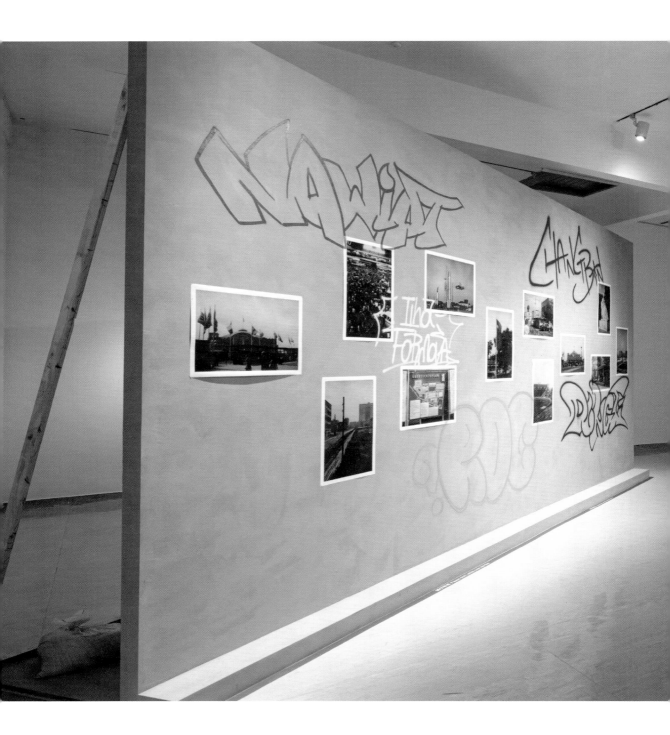

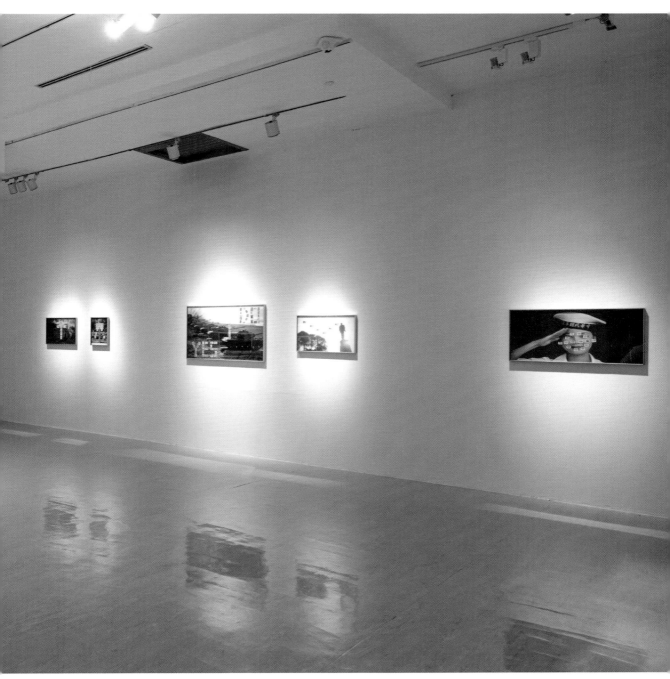

展覽現場照：國立臺灣美術館提供。攝影：ANPIS FOTO 王世邦。
On-site view photo courtesy of the National Taiwan Museum of Fine Arts,
shot by ANPIS FOTO (WANG Shih-Pang).

因為無名，所以幽靈；因為無邊，所以鄉愁。

The namelessness creates the spectre and the boundlessness nostalgia.

國家圖書館出版品預行編目(CIP)資料

覆寫真實：臺灣當代攝影中的檔案與認同 =
Covered reality : archival orientation and identity in Taiwanese
contemporary photography/
黃舒屏, 蔡昭儀主編. -- 臺中市 :
國立臺灣美術館, 國家攝影文化中心, 2022.05
160面 ; 18.5x24公分
ISBN 978-986-532-569-5(平裝)
1.CST: 攝影集
958.33 111004072

覆寫真實
真實

COVERED REALITY
臺灣當代攝影中的檔案與認同
Archival Orientation and Identity in Taiwanese
Contemporary Photography

指導單位	文化部	Supervisor	Ministry of Culture
主辦單位	國立臺灣美術館	Organizer	National Taiwan Museum of Fine Arts
	國家攝影文化中心		National Center of Photography and Images
發行人	梁永斐	Publisher	LIANG Yung-Fei
編輯委員	汪佳政、亢寶琴、黃舒屏、	Editorial Committee	WANG Chia-Cheng, KANG Pao-Ching, Iris Shu-Ping HUANG,
	蔡昭儀、林明賢、尤文君、		TSAI Chao-Yi, LIN Ming-Hsian, YU Wen-Chun,
	賴岳貞、曾淑錢、張智傑、		LAI Yueh-Chen, TSENG Shu-Chi, CHANG Chih-Chieh,
	陳俊廷、駱正偉		CHEN Chun-Ting , LUO Zheng-Wei
策展人、專文撰稿	賴駿杰	Curator and contributor	Jay Chun-Chieh LAI
主編	黃舒屏、蔡昭儀	Chief Editor	Iris Shu-Ping HUANG, TSAI Chao-Yi
執行編輯	林學敏	Executive Editors	LIN Hsieh-Min
展覽執行	臺中—陳力榆、臺北—林學敏	Exhibition Coordinators	Taichung - CHEN Li-Yu, Taipei - LIN Hsieh-Min
美術編輯	陳品含	Graphic Designer	CHEN Pin-Han
翻譯	余詠茵、黃亮融	Translators	YU Wing-Yan, Alex Liang-Jung HUANG
校對	林問亭、林學敏、鄭舒媛、	Proofreaders	LIN Wen-Ting, LIN Hsieh-Min, CHENG Su-Yuan,
	李佩芸、陳力榆、賴駿杰		LEE Pei-Yun, CHEN Li-Yu, Jay Chun-Chieh LAI
展覽日期	臺中：2022年4月9日至2022年7月3日	Exhibition Date	Taichung: April 9, 2022 - July 3, 2022
	臺北：2022年9月29日至2022年12月4日		Taipei: September 29, 2022 - December 4, 2022
出版單位	國立臺灣美術館	Publisher	National Taiwan Museum of Fine Arts
	國家攝影文化中心		National Center of Photography and Images
地址	臺中市40359西區五權西路一段2號	Address	No.2, Sec. 1, Wu-Chuan W. Road, 40359, Taichung, Taiwan, R.O.C.
電話	04-23723552	TEL	+886-4-23723552
傳真	04-23721195	FAX	+886-4-23721195
網址	https://www.ntmofa.gov.tw	Museum Website	https://www.ntmofa.gov.tw
	https://ncpi.ntmofa.gov.tw		https://ncpi.ntmofa.gov.tw
製版印刷	宏國群業股份有限公司	Printer	HK Printing Group, Ltd.
出版日期	2022年5月	Publishing Date	May, 2022
ISBN	978-986-532-569-5	ISBN	978-986-532-569-5
GPN	1011100349	GPN	1011100349
定價	新臺幣600元	Price	NTD 600